Shared Living

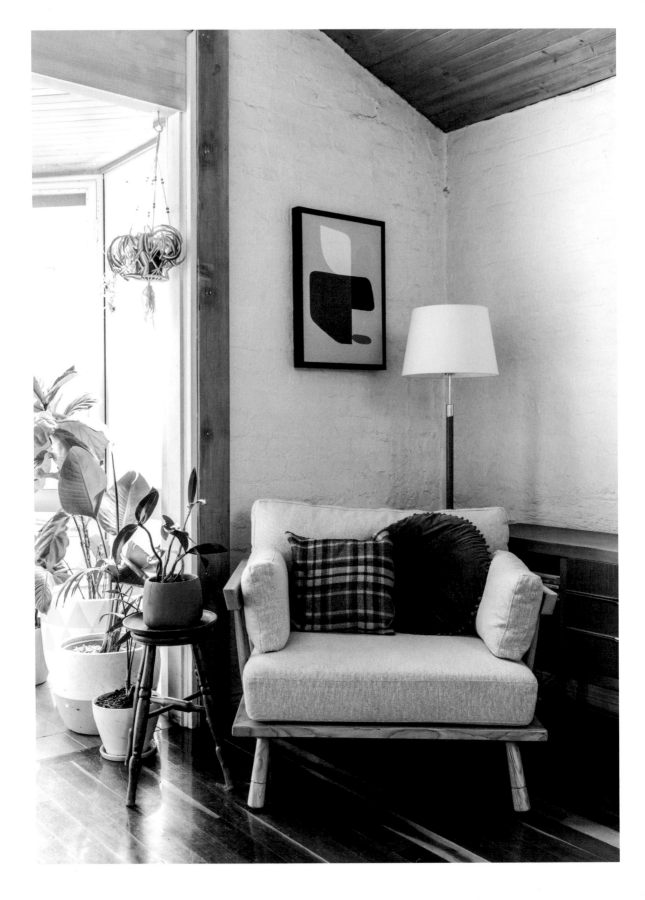

Emily Hutchinson

Shared Living

Interior design for rented and shared spaces

Thames & Hudson

Contents

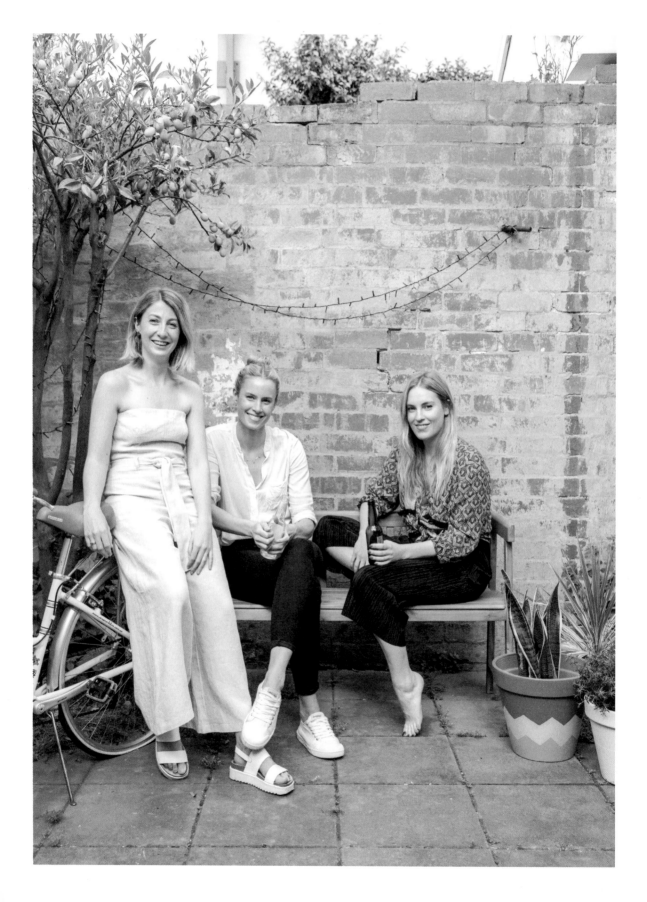

Introduction

I've lived in share houses for years, in New York, in Sydney and now Melbourne. With my strong interest in good design and great pieces, I have – at times – struggled with the interior design of the places I've shared. So often, share houses are portrayed in a negative light, but there is a new member of the share house: the grown-up.

Buying a house is now out of reach for many people, so share housing is becoming an increasingly common solution for a generation who aren't straight out of the nest. There's an established and mature demographic joining the share-house community. These people are more interested in creating a stylish, homely lifestyle rather than a transient one.

The challenge in grown-up share houses is to work out how you can still indulge your creative spirit, invest in pieces and make the space around you one you want to live, entertain, sleep and play in, regardless of whether you find yourself living with a group of friends or strangers.

My good friend Octavia (see page 77) says that to be a share-house decorator also means being resourceful. In her share house, she says, 'We care about style, but we don't all have the budget to go out and buy those designer pieces you see in glossy magazines. Instead, we hunt and gather – we find things on second-hand homewares sites, at garage sales and on the side of the road. When we do splash out on pieces, it's because we absolutely love it, but we treasure most the things that come with a story.'

It's not just about resourcefulness, but being open. Be willing to accept different styles, and to share your own style with others.

Since connecting with the housemates featured in this book, I'm excited for the future of shared living around the world. Hearing their stories of life at home and exploring their carefully curated spaces shows just how far the modern share house has come.

I hope that we can reconsider our view on the share house as being a transient space and instead, put time and effort into creating a place of warmth and welcome. At the end of the day, we all want to be able to walk through the front door, put our things down and feel completely at home.

Emily Hutchinson (left) with her housemates, Maddy Dixon (centre) and Felicity Burke (right)

Less is more

WHO LIVES HERE
Madeleine Murdoch, her boyfriend,
Daniel Evans, and Harriet O'Rourke

LOCATION
Melbourne

HOUSE SIZE
2 bedrooms, 1 bathroom

WORKING LIFE
Madeleine works in marketing
for Danish furniture company
Great Dane; Daniel works for
a bank; Harriet is a doctor.

OF PARTICULAR INTEREST
They live next door to a pub!

Madeleine, her partner, Daniel, and their friend Harriet all met at school in Brisbane and decided to collectively make the move to Melbourne for a change of scene. They found a small home in trendy Carlton and make full use of the cafes, bars and restaurants in the area. To decorate the small space they have gone for a mid-century style, choosing quality over quantity to fill their living room.

'Our mutual philosophy has always been "less is more". We all come from interstate, so we didn't have a lot to begin with,' says Madeleine. 'The challenge was making everything fit into our tiny little space while still ensuring that we had room to breathe. We have all begun to appreciate storage at a whole new level!' By using a minimalist approach each room feels bigger, especially the compact living room. The furniture is also high quality thanks to Madeleine working at Great Dane.

Everything that is brought into the house needs to be well thought out and agreed on by each of the housemates, otherwise there is a risk of over-crowding. One of their favourite pieces is the 1960s Percival Lafer terracotta-coloured leather couch in the living room, which Madeleine received as a hand-me-down from a previous workplace. Madeleine also looks out for pieces from op shops or the side of the road.

In such a small living room, a TV would have dominated the space. So to maximise the area, but still enjoy their favourite shows and movies, Daniel got a projector. 'We use the white wall to project on and sit the projector on the kitchen bench top,' Daniel explains. 'It works perfectly. We often watch *Mad Men* together.'

Cooking is another way these housemates come together and their modern kitchen helps to produce some top meals. 'We all love cooking together and work great as a team. In winter, we love slow roasting a leg of lamb in the oven for eight hours,

filling our little home with warmth and that amazing smell!' says Madeleine.

While the living area offers the ideal sharing ground for the three housemates, the layout of the house means privacy is also easily achieved, which is an ideal situation when living with a couple. The two bedrooms in the Victorian-era house are at opposite ends. Harriet lives in the original front of the home, while Madeleine and Daniel's bedroom is part of the extension at the back that leads onto a small courtyard. The mid-century style throughout unites the home's differing eras, as the sleek timber furniture, plants and pottery mesh with both the older and newer parts of the architecture.

While Madeleine, Daniel and Harriet are happy with their home's overall look for now, future decorating plans involve getting more plants. 'The more plants the better! We want to turn our home into a jungle,' says Harriet.

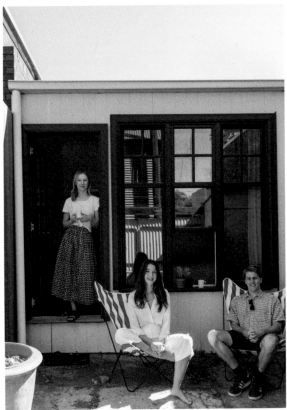

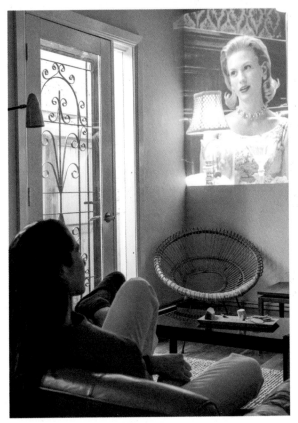

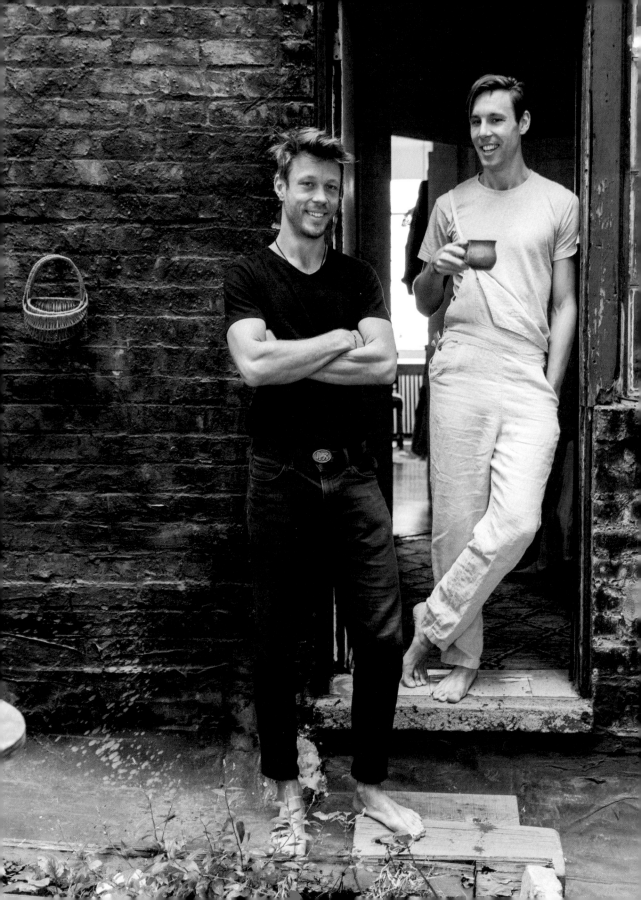

A brotherly bond
in Brooklyn

WHO LIVES HERE
Simon Roberts (left) and
Ward Roberts (right)

LOCATION
New York

APARTMENT SIZE
3 bedrooms, 1 bathroom

WORKING LIFE
Ward is a professional conceptual
artist with photography as his main
medium; Simon is an urban farmer.

OF PARTICULAR INTEREST
The apartment used to be an old
storage unit, with slatted window
frames, which tell of its history.

Most people who live in New York City would count themselves lucky. But these two brothers, who are originally from Melbourne, are even luckier than most. Both Ward and Simon won the green-card lottery, which meant they were able to pack up and settle down in the city of bright lights and big dreams.

Their apartment in Brooklyn, where they have been living for just over a year, is their sanctuary, away from the hustle and bustle on the streets below. The three-bedroom apartment has a small kitchen/dining space and an outdoor area – a rare commodity in the city.

The brothers have worked with the landlord to improve the home with small touch-ups, which benefit themselves as well as future tenants.

'We worked really hard to have a good relationship with our landlord because essentially we fixed up the space,' says Ward. 'I wanted to actually improve the place. Paint it some nice colours, get nicer light fittings, little things that don't necessarily cost a lot, but give the home a better appearance.'

The colour palettes on the walls aren't too dissimilar to the colours in Ward's photography. Soft pastels have drawn Ward's eye to many urban settings around the world. His work for his books *Courts* and *Courts 2* documented dreamy sporting courts. He's a strong believer in picking a palette when decorating, using it as your base and building from it with complementary colours.

Ward regularly visits garage sales and thrift stores in New York to find new gems to take home and decorate with. While he admits thrift stores can be expensive in the city, he argues that if you do the proper research you can find some incredible pieces. He was fortunate enough to work in a thrift store in Bedford–Stuyvesant during his first summer in Brooklyn and picked up a few prized possessions. A weathered, green-coloured mirror that lives

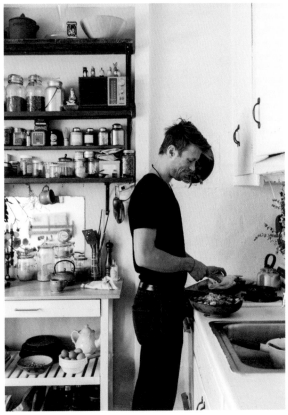

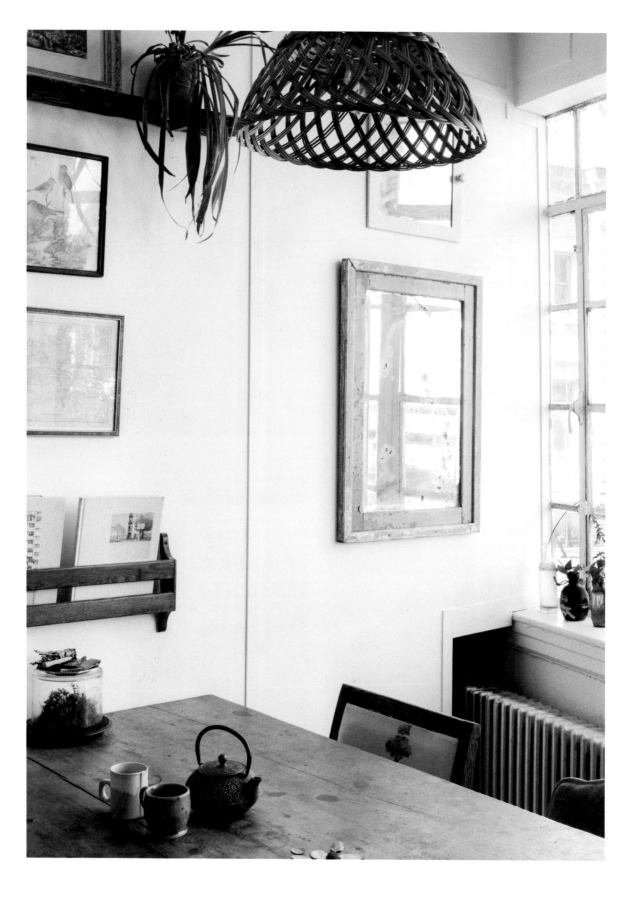

in the kitchen/dining area is a particular favourite. The red lampshade in Ward's room was purchased in Hong Kong, where it was originally used by a local butcher. He is also very proud of the bed frame in his bedroom, which was once king size before he cut it down to a double.

While Ward heads up the colour palette of the house and second-hand decor, Simon uses his green thumb to add plant life to the apartment. His expertise as an urban farmer means he can grow healthy plants within a largely concrete setting. 'Decorating a place, particularly in New York, is in large part bringing nature into your house because there's not a lot of nature we have access to,' says Simon. He does this with a variety of potted plants, dried flowers on the windowsill and planter boxes outside.

The pair has found their brotherly bond stronger than ever while sharing this space. 'We're very respectful of each other's perspectives, much more

so now than in the past,' says Simon. 'When you move in with someone, it can be really hard to ascertain what their values are, what really drives them. But when you're siblings, you naturally have very similar values, which ultimately lead to a more trusting relationship.'

'There's that level of trust that you're not going to get annoyed about something the other one is doing and just get another housemate. If there's an issue, we sit down and say, "Okay we need to improve this,"' says Ward. 'And because we're brothers, I can do silly things, like morning dances in the kitchen to bring some good energy into the space,' Simon adds.

As two Aussie boys living in a New York hotspot, Ward and Simon often have visitors from back home staying in their third bedroom. They both love hosting and regularly cook up a feast for their guests before hanging out on their rooftop with a few drinks.

TIP:

If you don't have the advantage of an outdoor area, bring nature inside by adding plants to every room. Surround yourself with greenery and enjoy healthier air without having to leave home.

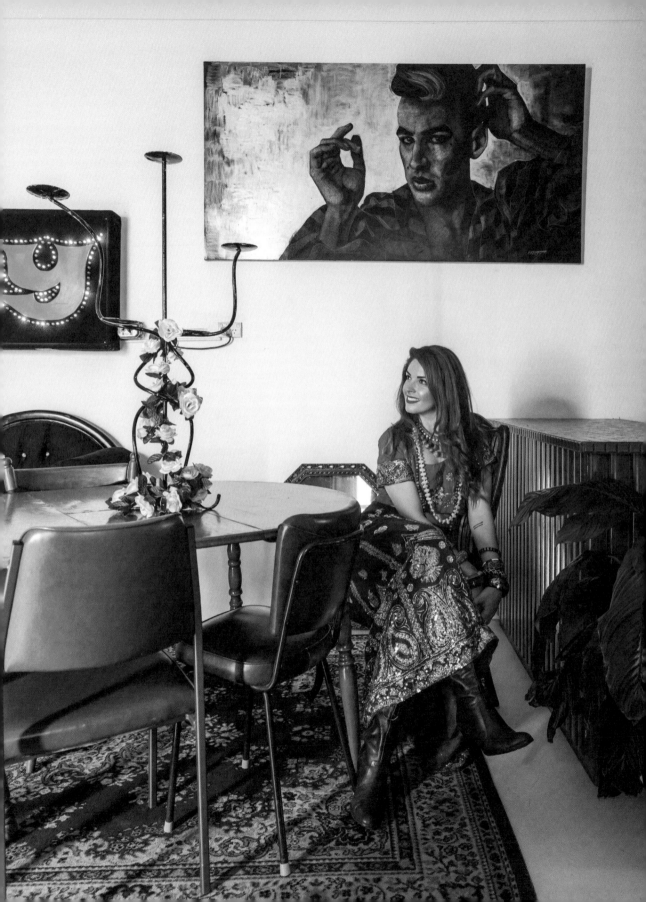

The Naughty Corner

Many people walking past Brendan, Alicia and Roxy's blue warehouse in Marrickville, in inner-west Sydney, stop to peer inside at the wonderland of costumes, glitter and, of course, creativity.

All three housemates are performers and Brendan has collected an impressive array of fierce costumes, not to mention some special pieces of furniture from sets he has designed, including *The Great Gatsby* and *Moulin Rouge*.

What makes this share house special is that it's not just a place to live, but somewhere the three 20-somethings can come together to share ideas and ambitions while they navigate their way through this stage of life.

WHO LIVES HERE
Brendan de la Hay, Alicia Quinn (aka Lou P Scarlett) and Roxanne Van Zyl

LOCATION
Sydney

APARTMENT SIZE
Shopfront, photo studio, lounge, 2 loft bedrooms, joint bathroom/laundry and a caravan in the yard

WORKING LIFE
Brendan is an entertainer, designer and artist; Alicia is a singer and songwriter who also performs as a burlesque artist and works as a gym instructor; Roxy is a singer who also styles for clothing brand Tree of Life.

OF PARTICULAR INTEREST
The warehouse has a colourful history. For over sixty years it has housed mixed businesses, including a hardware store, a group of welders, a family with a milk bar and a couple who juiced sugar cane.

How did you meet each other?

Brendan: Alicia and I met in 2010, while studying Music Theatre at the Australian Institute of Music. Roxy is our newest clan member, and we met her via friends on Facebook. Alicia and I had the idea of creating a showgirl-style caravan in the yard using one of my parents' caravans, but then along came Roxy! Serendipitous.

Roxy: I had put my caravan into storage while I looked for a place for it. I posted an ad on some Sydney house-sharing pages on Facebook and a friend tagged Alicia, who then got in touch with me.

How did you find your share house?

Brendan: I have been obsessed with warehouses for quite some time. However, it was a pretty unattainable goal as a full-time artist (with an unpredictable income) living alone in Sydney, who often travels for work. But … I found this one online, and it was first appealing because

it is the ONLY blue warehouse in the entire area (visual person first), and also because it is a freestanding building close to a train line with a private yard! This comes in handy for design projects, building set pieces, spray painting headdresses or general outdoor party BBQ vibes. Our warehouse was also part of a scandal at one stage, featuring the very sad passing of a previous tenant. We send our biggest love and wishes to him wherever he is now in time and space. He's part of our home's history, and his spirit is loved. We sometimes get visits from his brother and ex-housemate. Rest in peace, buddy. x

Alicia: Brendan and I decided to move in together. We were both house hunting for a month or so but he found this locale. He was in desperate need of a place to store his costumes!

What do you like about your neighbourhood?

Brendan: We have lots of cute cafes very close by, and we are also surrounded by some of the quirkiest colour warehouses.

Because of the bizarre buildings, there are always lots of fashion shoots going on in back alleys. Even *Vogue Australia* has shot on our street! We have the retro yellow smash repairer, the red factory, our little blue warehouse and, of course, the bright pink 'massage parlour'.

Alicia: The inner west is the best! There are lots of hidden cafes and bars, and lots of creatives in the area. People are friendly and there is always a gig or a festival going on close by.

Roxy: It's a pretty neat location. It's right on the outskirts of the main inner-west hub and not too far from everything else this city has to offer.

What is your secret to a happy household?

Brendan: Communication. And wine.

Alicia: Communication! Being open and understanding. Being aware of what housemates need to be happy and also being open to talk about concerns without taking anything

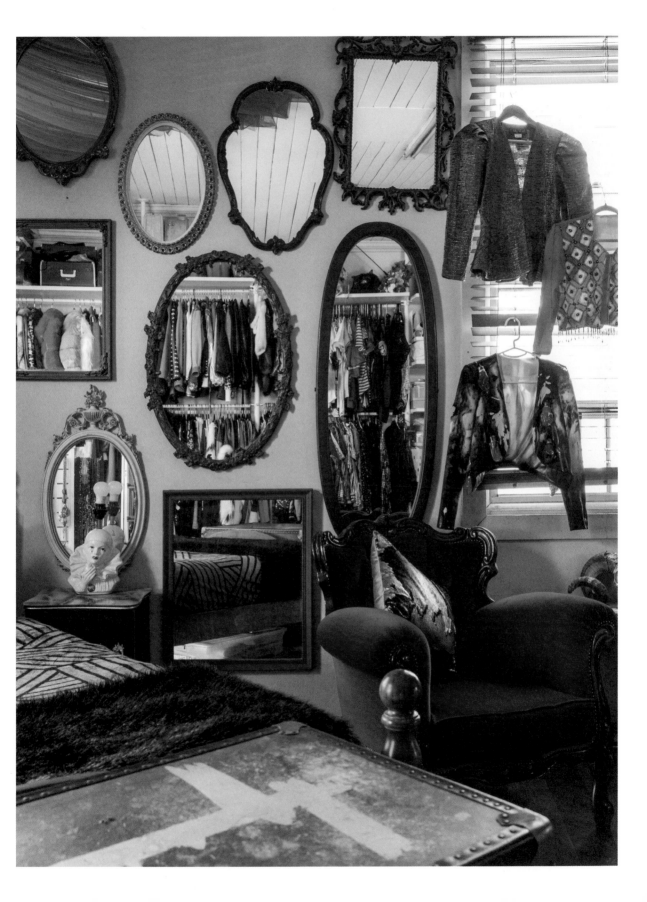

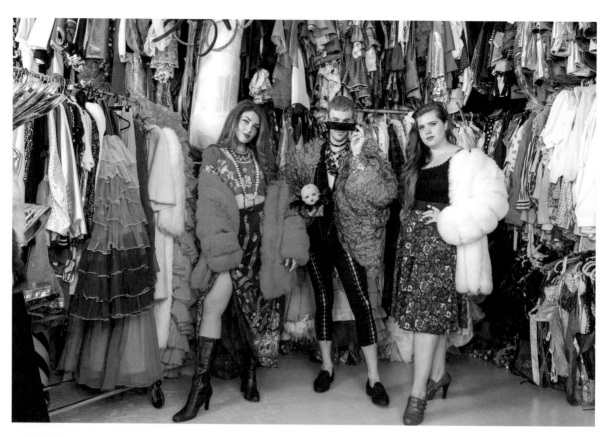

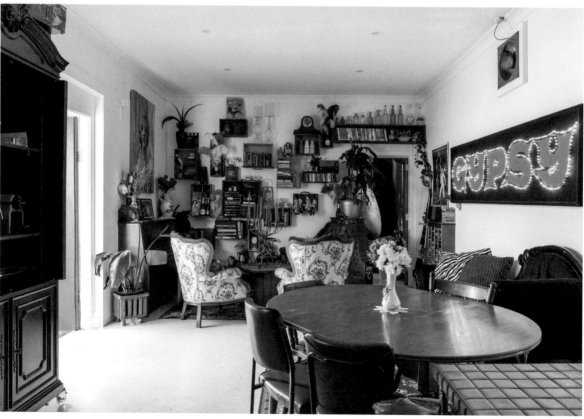

personally. Also taking time to have a wine, a good laugh and debrief at the end of the day.

Roxy: It's a very creative and encouraging environment. We each have our own projects and are working towards our own creative goals, which is cool to see and be part of.

How did you decorate your house together?

Brendan: Being a designer, and collector of vintage, the household has ended up being mostly made up of leftover pieces from photo shoots, stage shows, film shoots and events I have designed or styled. We have furniture pieces from Baz Luhrmann's *Moulin Rouge* and *The Great Gatsby*. We have a portrait painted by German–Australian artist Kathrin Longhurst. We have the light-up sign from the original Australian production of the musical *Gypsy*, which still works! Plus a huge range of quirky knick-knacks used for my productions at the Sydney Opera House, events at places like Old Parliament House in Canberra, and also some bits and bobs left over from a cover shoot I worked on for *Vogue*.

Alicia: There was a big hustle and lots of exciting discussions about how we wanted the place to look at the start. After picking a colour scheme (red and pink) it took us a month to paint everything, get new lights, consolidate and find furniture, and install shelves. We definitely called in a couple of favours from our families and friends! Over the year we've lived here, the beautiful and glamorous clutter in the living space and in my bedroom has grown. I have to admit the delectable bookshelf wall was all Brendan, and periodically we do get to enjoy lush items from shows he is designing, which is fab!

Roxy: We pretty much started with a blank canvas and went from there. It was a gutted warehouse so we painted everything (including the floors) and then added other pieces bit by bit. That part was mostly by the resident stylist Brendan de la Hay.

What is your favourite piece of furniture or decor in the house?

Brendan: Definitely my red-velvet armchairs upstairs in my room, very closely followed by the *Moulin Rouge* corner love seat.

Alicia: My grandparents' upright piano.

Roxy: The entire lounge is a big focal point, I think. With the *Gypsy* sign and *Moulin Rouge* love seat, the feature wall, Marilyn above the piano … it's a nifty space.

Where do you spend the most time?

Brendan: The costume shopfront and photo studio are very transient places because my productions are ever growing and changing. I would definitely spend the majority of my time in these rooms, as I work around the clock. Plus it has the nicest lighting during the day, and I love to watch the local foot traffic baffled by the room filled with sequins, glitter and fur.

Alicia: Either in my bedroom or the living room.

Roxy: Probably my room (caravan) mostly, also the lounge.

What do you like doing together as housemates?

Brendan: We love to support each other's art. Taking a night to collectively go and support one another is important at The Naughty Corner. As artists, it's incredibly helpful to have like-minded people endeavouring to create bizarre things so that you can bounce your ideas around and help each other improve.

Alicia: Performing and bouncing around ideas for shows! Brendan and I do a lot of cabaret/burlesque/singing gigs together and that's always a ball too. We also enjoy a good dinner party, seeing live music or even having a sneaky beach trip to Coogee.

Roxy: It's great when we're working on things or sitting around spitballing ideas for shows or events.

Do you feel as though your time in this share house is one you'll look back on with good memories?

Brendan: Absolutely. I actually really love living by myself, and have done so for quite a long time, but it's been fascinating to watch myself expand as a human being by having other people around.

Alicia: Yes! So many good memories! Fun parties, exciting and fulfilling work, and constant streams of creative and thought-provoking discussion!

Roxy: One hundred per cent! I'm still relishing the novelty of living in a big city in a caravan. I still wonder how I got here sometimes.

What have you learned about yourself while living in this share house?

Brendan: Being one of those people who would appear to be an extrovert, I have learned that I actually regenerate by spending time alone. But I am pushed further with my ideas and energised more by being surrounded by others fuelling their own creativity. It's been great to find a balance.

Alicia: I thrive living with other creatives. I love being able to talk about ideas and projects. I love feeling comfortable to explore and present myself as my most bright and heightened self. And I love being surround by positive and supportive people who understand and share the passion to constantly better their art.

Roxy: We're all these ever-changing entities. Everything has changed within my first year of living here. I've been slowly coming out of my shell in areas of my life such as style, performing and creativity. Living in such a creative environment means a lot of things are experimental – some trial and error, or trial and succeed! So it's been an educating experience for me and is pushing me towards achieving what I set out to do when I first came to Sydney.

Colourful collections

WHO LIVES HERE
Jamie Brown (left) and Jackson
Payne (right)

LOCATION
London

APARTMENT SIZE
2 bedrooms, 1 bathroom

WORKING LIFE
Jamie is a visual artist and spatial
designer; Jackson produces films
and stills shoots.

OF PARTICULAR INTEREST
There used to be train station called
Mildmay Park beside the tracks
outside their house. It opened in
1880 and closed in 1934.

The line between clutter and collection can easily become blurred. The home shared by housemates Jamie and Jackson boasts impressive collections of knick-knacks and decor, which Jamie refers to as his 'clutter'. In fact, their home serves as a perfect example of eclectic decorating where collections of loved objects – rather than a particular style – dominate a space. Objects that come with stories can connect owners to their home.

Jamie and Jackson met at university in Brighton and quickly became friends. So when a room became available in Jamie's house in northeast London, Jackson says it was a no-brainer. Because Jamie was already established in the house, he was responsible for most of the decorating. However, Jackson has contributed to the decor through

some welcome additions, such as artwork in the living room.

From books to artwork and plants to records, collections can be found throughout the two-bedroom house, making it hard to choose just one favourite piece of decor. But Jamie does have a soft spot for the salvaged, hand-cut acrylic tool signage that he found in a local hardware store, and the drinks cabinet in the living room. 'I picked up the incredible sideboard bar at Portobello Market. It was love at first sight although it felt rash at the time, even though it was a bargain. So glad I did, it owns the front room,' says Jamie.

Rare for an abode in this area, Jamie and Jackson have outdoor space. 'The back terrace is a real haven – surrounded by lush gardens and foxes,' says Jamie. They also have an all-important BBQ out there, which gets a

TIP:

Find items that not only look great but also have a story to tell, connecting them to you and your home.

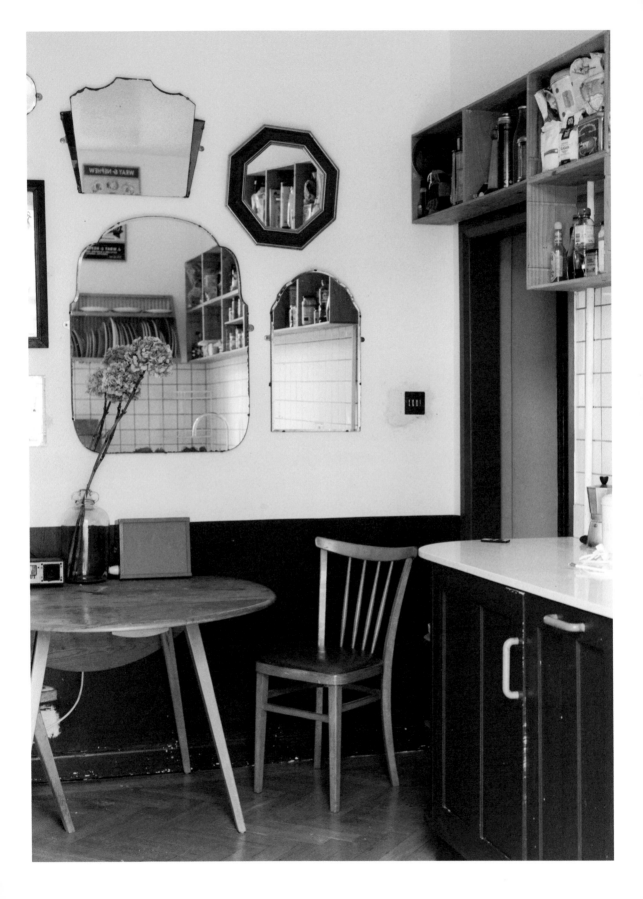

regular workout during the warmer months of the year. Jamie loves being able to open up the windows and welcome in the outside. 'The light that pours in and the breezes that gust through the flat from the south-facing windows are special,' he says.

Jamie painted the living room a deep shade of green, which he did to achieve a gentlemanly and lush jungle-like feel. In the kitchen the royal-blue cabinetry is a nice contrast to the living room, creating defining spaces. The collections continue there with a wall of antique mirrors Jamie has collected over time from flea markets, car boots and the internet, which he says was a fun way of creating a big mirror.

'I also added some cacti and an old Rod Stewart mirror to the selection of mirrors on the kitchen wall. That's probably my favourite piece that I've added to the gaff. Rod is a legend,' says Jackson.

The kitchen is not only charming with its eclectic collections, but also highly functional. Open shelving stores ingredients for easy access. A magnetic knife strip hangs next to the stove and utensils are kept together conveniently in a storage cylinder. There would be no mucking around looking in drawers while cooking in this kitchen, when Jamie fries up his go-to dish – fish tacos.

Whether it's clutter or collections, each curio Jamie and Jackson add to their shared space makes it feel more like home. That feeling of connection to a house can often come from being able to look around a room, finding a detail you've added and remembering the story behind it.

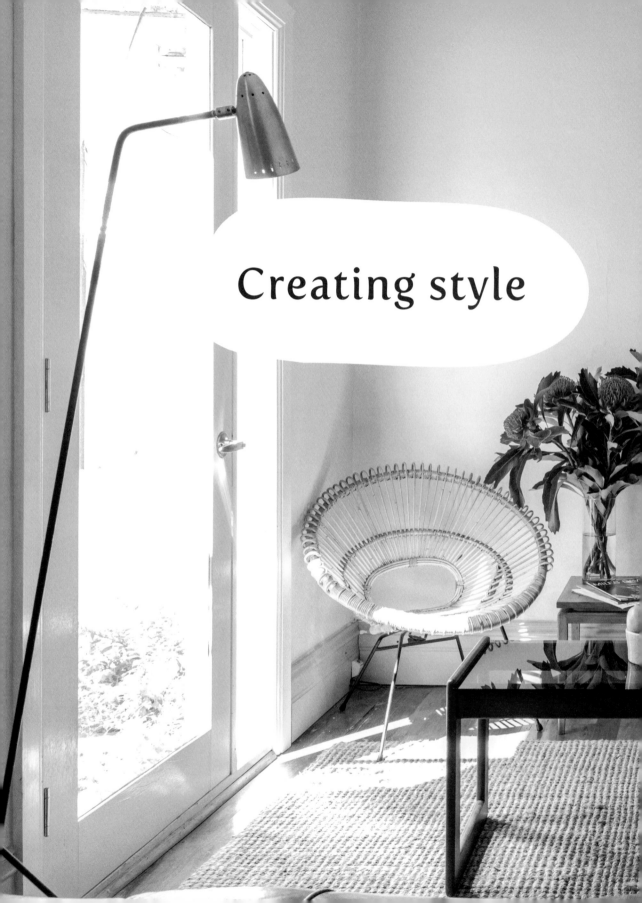

Creating style

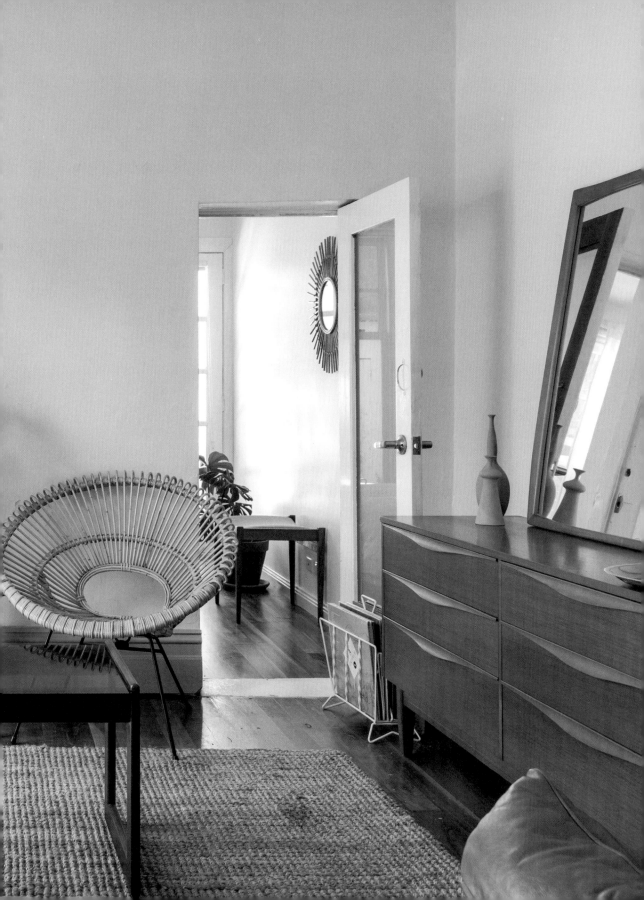

Decorating a rental

Many share housers can feel stumped when it comes to decorating their new digs. For some, it's their first chance to unleash their inner stylist and it's hard to know where to start. Even for those with a natural talent for decorating, piecing together a share house can be tricky. It involves merging styles, knowing the rules of rentals and artfully filling those frustrating blank spaces.

However, that doesn't mean you can't put in the effort to decorate your rental and make it feel like home. In fact, most landlords encourage it. From a landlord's point of view, they want a tenant who is going to look after their asset. Someone who will treat it as their home and not just a transient space. This means that by working with your landlord, you not only foster a good relationship with them, but also improve their property and your lifestyle – it's a win-win situation.

Of course, this doesn't mean you can just do whatever you want. At the end of the day you may come and go from a rental, but the landlord is the one who is stuck with your design decisions when you leave.

It can differ in every country and state, but there are some general rules of thumb for knowing what you can and cannot do when decorating a rented property.

1. DRILLING HOLES

Don't make holes in the wall without checking with the landlord, especially since it's easy to go wrong. Regardless of the type of wall – brick, plaster or wood – drilling a hole into it isn't always the best design decision.

If your landlord isn't happy about you drilling through the walls there are alternatives, such as adhesive hooks and picture hanging systems (using the cornice between the ceiling and the wall). You'll often find picture railings in older homes.

2. PAINTING WALLS

Don't paint the walls before checking with the landlord. They will usually want to know about your plans, especially if it's a colour other than white.

Sometimes a paint job can add value to the property, so always run this decorating option past your landlord. An alternative to painting could be wallpaper or wall decals. It's possible to have a lot of fun with these.

3. CARING FOR THE GARDEN

Many landlords make maintaining the garden part of the signed lease agreement. Forgetting to water it or letting it become overgrown with weeds is not going to impress.

If you do have a garden, count yourself lucky and not only look after it, but improve it. Planting flowers or growing produce for your dinner will make your rental feel more homely.

4. CHANGING FIXTURES

Don't throw away old fixtures. It's okay to take down ugly blinds or outdated light fittings but don't throw these away. Keep them in a safe place and reinstall them when you move out.

Decorate with curtains and pendant lights of your choice. You can always take these with you when you leave, and it will make a world of difference to your home's style while you live there.

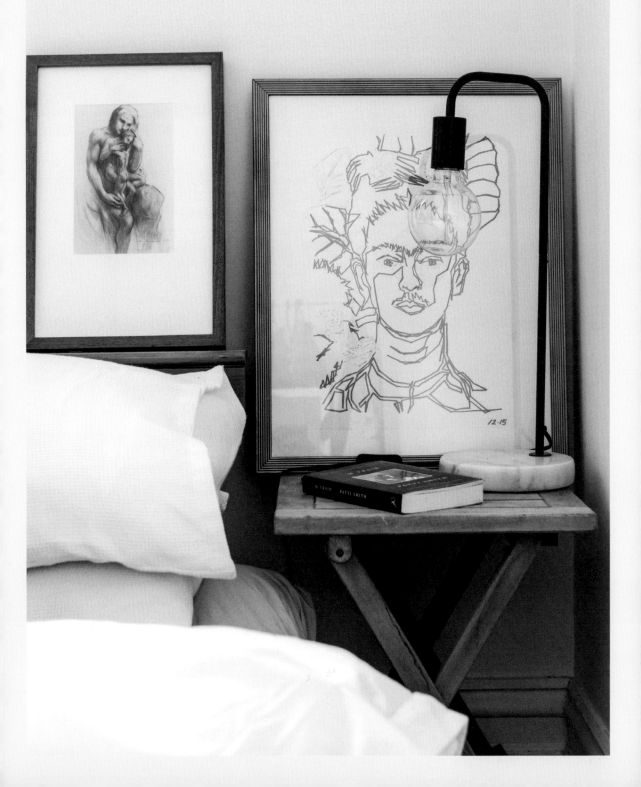

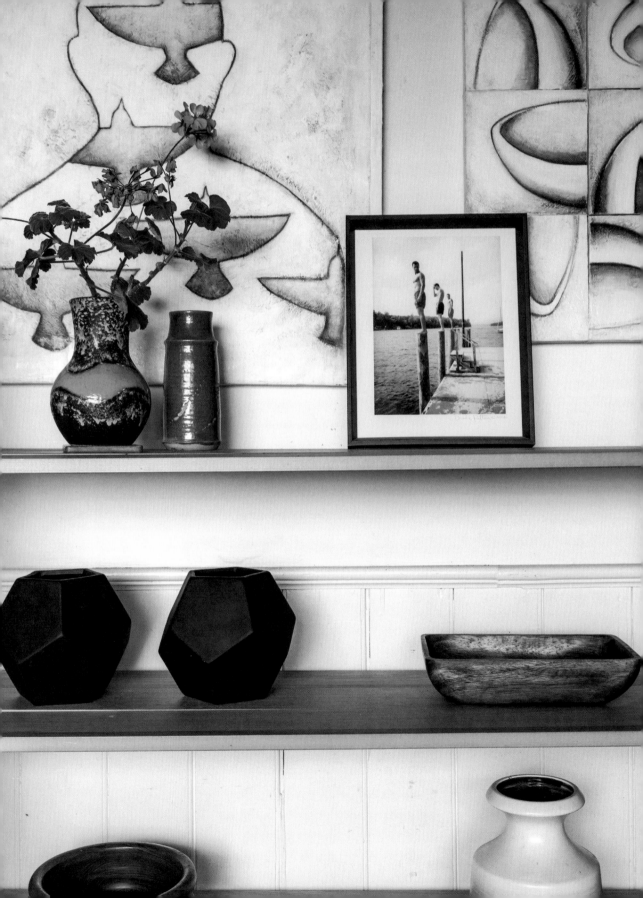

Merging styles

The ideal situation when decorating a share house together with housemates is that you all have the same style. When you each come with an individual style, it can feel like you're competing for space.

While bedrooms offer a private decorating canvas, the public spaces of the house – the living room, bathroom, kitchen, entry and outdoor area – need a more inclusive approach.

Being able to merge styles is the key. Merging styles is about being open to other people's choices in design, as well as sharing your own ideas. This will create a sense of unity in the household that's both seen and felt.

1. SHOP TOGETHER

There will, of course, be some design dilemmas. The number one dilemma is when a housemate brings something into the shared space that doesn't gel with everyone else. The solution is to be honest. That mannequin head nicknamed Sandra on the TV unit may not bother your housemate, but looking at it every night will bother you. So you'd better speak up about it before Sandra becomes a problem.

Try to shop together. Picking something out collectively often saves the awkward vetoing of a piece that just one housemate has chosen.

2. MANAGE CONFLICTING STYLES

It can be a problem when housemates have completely conflicting styles. For example, merging gothic and shabby chic would be a struggle for even the most experienced interior designer. In this situation, stick to neutral basics for the big things (such as couch, rugs and tables) and build character with non-permanent decor (such as pottery, artwork and cushions).

3. BREAK STYLE RULES

Keep in mind that it's okay to break the rules when merging styles. There's something special about a space where the decorators have chosen to use the things they love rather than following trends strictly. This way, the personality of each housemate shines through and there are more layers to the home's story.

4. LIVE AND LEARN

Above all, embrace and learn from your housemates' design choices. What you discover might pleasantly surprise you.

Filling in the gaps

There are little opportunities all around a share house where you and your housemates can add style and character. It's not just about the big things – the sofa you choose together, or what colour you paint the walls. Interesting corners and structural surfaces offer plenty of potential to create vignettes that allow the personalities within the house to emerge. These thoughtful final touches can be the difference between a place that feels transient and a home that feels permanent and well loved.

1. THE ENTRY

The entry is a hard-working part of the house. It's a high-traffic area that fields bags, coats, shoes, keys, mail and possibly even a bike.

A side table, to plonk your things down on when you arrive home, will work wonders, as will baskets for storage or a tray for keys and mail.

To set the stylistic tone of the home and create a feeling of welcome, try adding a vase of foraged greenery, a lamp or a candle. You can also define the space with a colourful rug, or a collection of artwork or mirrors. Above all, make sure your style starts at the front door.

2. THE STAIRCASE

The climb up and down the stairs doesn't have to be boring. To create a talking point, add some photographs or artwork to the walls.

Plants on stairs work well to soften hard edges, or, if space allows, a small seat on the landing can double as a quiet reading nook.

3. THE WINDOWSILL

Windowsills provide the perfect place for tiny potted plants. They will love the sunlight and you'll love the green view.

Try an array of low-maintenance succulents, or line the sill with a variety of fragrant herbs.

4. THE FIREPLACE

Many older homes have non-working fireplaces that create a quirky small space to decorate. Don't shy away from stacking the hearth with books or adding some colourfully painted logs for dramatic effect. As always, plants are a great choice for this otherwise unused space.

5. THE MANTELPIECE

If you're lucky enough to have a mantelpiece, don't let it go to waste. This often gracious and formal feature can be the focal point of a room and is the perfect place for a mirror or any carefully arranged collection.

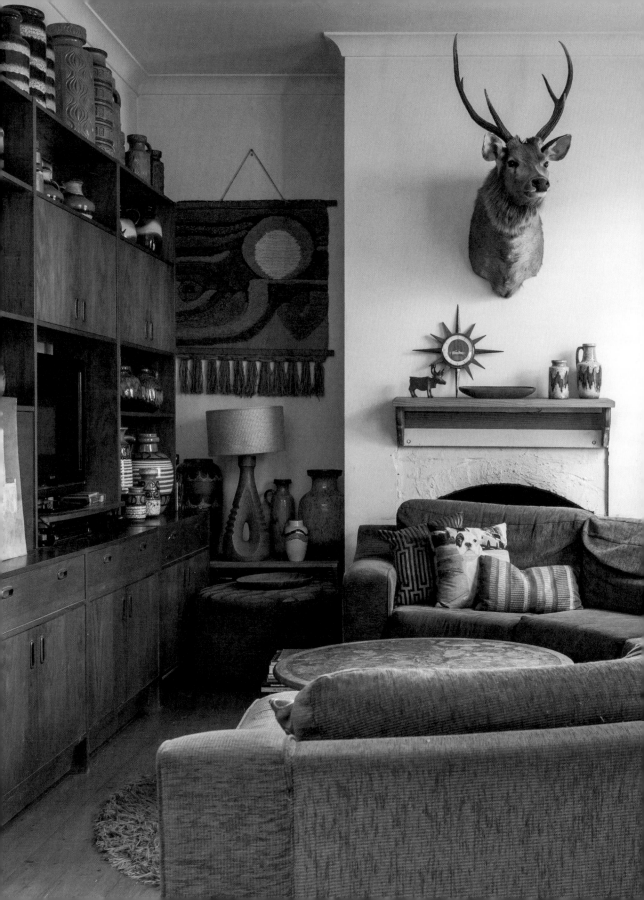

When Madonna and mid-century unite

WHO LIVES HERE
John Hendricks and Ricky Beirao

LOCATION
Melbourne

APARTMENT SIZE
2 bedrooms, 1 bathroom

WORKING LIFE
John finds and sells mid-century furniture on eBay; Ricky is a cafe manager and professional drag queen.

OF PARTICULAR INTEREST
The two housemates met while waiting in line for a one-off Madonna concert in Melbourne.

As soon as you walk into John and Ricky's abode in the inner-city Melbourne suburb of Richmond, you get the sense that you've travelled back to the 1950s when mid-century design was king.

John is a professional 'eBayer', collecting mainly mid-century pieces from antique shops across the state and bringing them back to his share house. Of course, there are many pieces he simply can't let go of and they have found a new home with him, including Bruce the deer head who watches over the living room.

Each piece is fascinating. From the impressive West German pottery that lines the shelves, the stunning retro leather armchairs and the circular couch in the living room, to the hanging planters in old school macramé, you feel you need to browse before settling in.

John has lived here for seven years and Ricky for a year and a half. John rules the roost in terms of design and describes himself as a hunter and gatherer of sorts. 'I find furniture for everyone. I enjoy it. If someone says to me they need something in particular, I'll go out and find it for them,' he says. His hot tip for house sharers is to take a sample of the wall paint when you move in and have it matched at the hardware store. It means you can hang as many paintings and plants as you like and just paint over the patches when you leave the house.

Ricky's style is in contrast to John's – he prefers clean and modern. 'I remember the first time I moved in and I said to John I was going to Ikea to get some things and he was horrified,' he says. 'We have different styles, but I like the

TIP:

Decorating doesn't have to be expensive. Save money and shop sustainably by picking up preloved furniture and knick-knacks online.

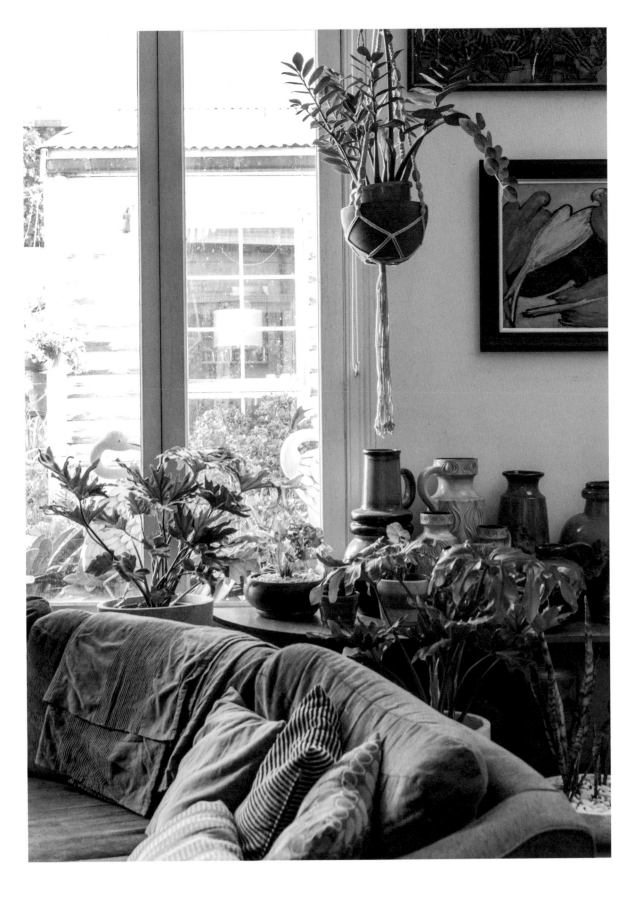

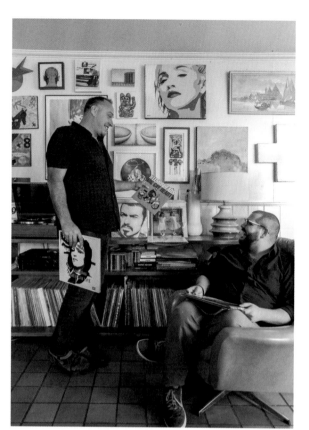
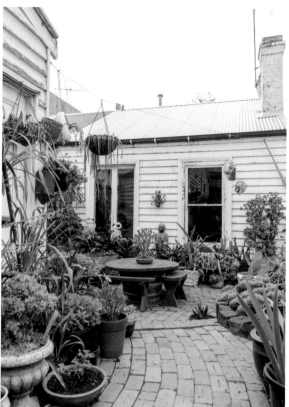
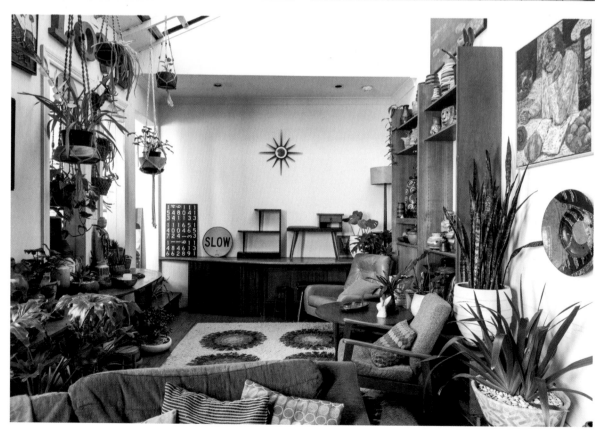

way the house is decorated –
it's where I come and feel
really comfortable.'

It's not just their decorating
styles, but also their personalities
that differ. John grew up in the
country and loves nature and
relaxing at home, while Ricky,
who is originally from Brazil,
thrives on the energy of the city
and regularly stays out on the
town for his drag performances
as Rhubarb Rouge.

However, the uniting factor
that brings these two housemates
together is Madonna. She's the
honorary third housemate in
this share house. Her presence
is felt everywhere, from the
artwork to the bathroom, which
is wallpapered with pages from
Madonna's erotica book, to
her music. John's vintage vinyl
collection of 700 records includes
300 Madonna albums. 'That was
one of the main reasons I moved

in with John. He said Madonna
will play 24/7 in this house,'
says Ricky.

It's not just inside where you'll
find collections, but outside
as well. John was formerly a
gardener and has populated the
back courtyard with an incredible
number of potted plants. Despite
having a brick layered surface
to work with, it hasn't stopped
greenery still finding a place in
this home.

'The garden changes seasonally,
but also with my mood,' says
John. In this background
paradise where John and Ricky
catch up on sunshine, you'll find
jade, canna and iris with some
agave and echeveria. And of
course the pots can move with
him if he ever changes houses.

It's not hard to see why
these two housemates aren't
in a hurry to leave this inner-
city sanctuary.

TIP:

Even the most
barren of outdoor
spaces can come
alive with potted
plants, which look
great against
backdrops of
exposed brick
and concrete.

A NYC loft brings five housemates together

WHO LIVES HERE
Bianca Ruthven, Greg Mailloux, Caitlin Daly, Mathew Ein and Katherine Freer

LOCATION
New York

APARTMENT SIZE
6 bedrooms, 1.5 bathrooms

WORKING LIFE
Bianca is a collections management consultant at the Metropolitan Museum of Art; Greg is a production sound recordist; Caitlin is a consultant; Mathew is a video editor; Katherine is a multimedia designer.

OF PARTICULAR INTEREST
The loft has a stain on the ceiling that Greg suspects is a blood spatter.

New York has a long history of loft living, which reached its peak in the 1950s and 60s when artists rented lofts for as little as $100 a year. These five housemates living in a Brooklyn loft are definitely paying more than that but agree that the location and space their home has to offer can't be beaten.

The classic industrial style of the loft means that there was already a beautiful canvas for the housemates to work with. Architectural features, like the exposed red piping in the living room and the steel-framed windows, hint at the home's history.

Greg, who has lived in the loft the longest, has been the principal decorator. Many of the pieces he has added have been collected over time. A 1970s Coca-Cola cooler was passed down to him through his family. The red cooler matches the huge couch, which is the centrepiece of the living area and accommodates all five housemates. Fairy lights

and festoon lighting have been used to decorate the beams and roof, enhancing just how high these ceilings are and the impressive cornicing above.

While the living area, dining and kitchen all feel like one room, a small breakout area next to the large windows provides a retreat. A comfy brown leather couch, potted plants along the windowsill and a few pieces of hanging art are all this area needs to make it a go-to destination when a housemate wants some downtime.

With so many diverging tastes in the loft, it comes as no surprise that merging styles was a daunting process, but Bianca explains that it worked by focusing on the design elements that were mutually accepted rather than trying to push for the ones that weren't. 'I think it takes the right group of people to strike a good balance and have good communication. Greg and I, for example, have different

TIP:

Draw attention to high ceilings with lighting. It shows off the space while still keeping it cosy.

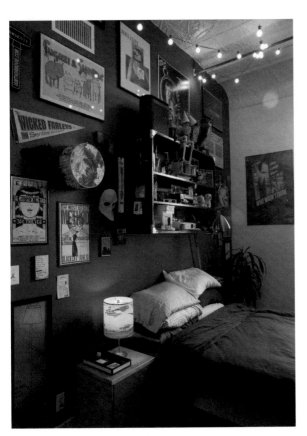

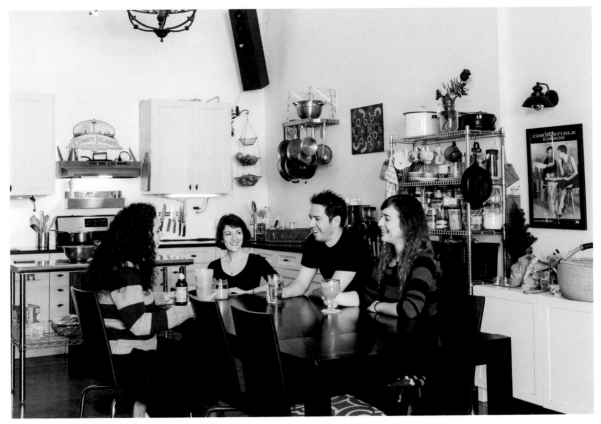

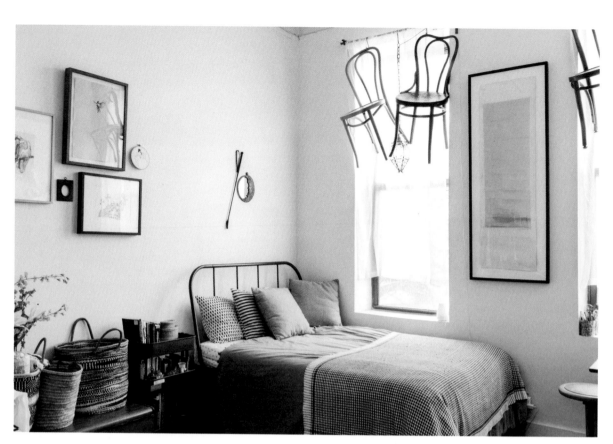

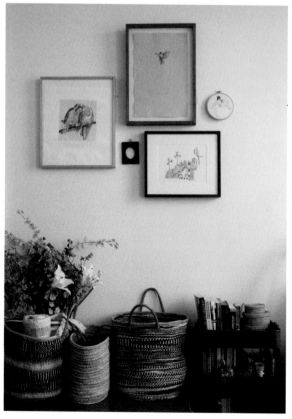

approaches to decorating, but we both share an interest in house plants, so we put our focus there in the common spaces, then treat our personal spaces well ... more personally. It also helped that some of us, Caitlin for example, isn't too strongly opinionated about decorating,' Bianca says.

While Greg prefers a more densely decorated home – describing himself as a 12-year-old trapped in a 39-year-old's body when it comes to his styling – Bianca is at the opposite end of the spectrum. 'I lean towards a more minimal, or at least intentional, decorating style,' she says. 'When you live with a lot of people, there is a tendency to be constantly bringing things in, but it's hard to get people to agree to take things out.'

The bedrooms show off just how different these housemates' styles are. While Greg's room is layered wall to wall with eclectic decor, including movie posters, figurines and records, Bianca's bedroom is light and airy with minimal pieces. The pared-back artwork and woven baskets for storage create a subdued undertone to the room. Her cherished bentwood chairs also found pride of place hanging at her windows and have become an eye-catching feature.

With five people under one roof and living different schedules, all the housemates agree it can be difficult to get everyone together. 'Inevitably one person can't make it, but we have either a dinner or brunch together every four to six weeks and complain about whichever person couldn't make it. It's fun-loving. Also, Greg hosts movie nights pretty regularly,' says Bianca.

They also always stay in contact to ensure that the apartment is running smoothly and everyone is happy. 'This usually involves a long series of texts and witty GIFs,' says Greg.

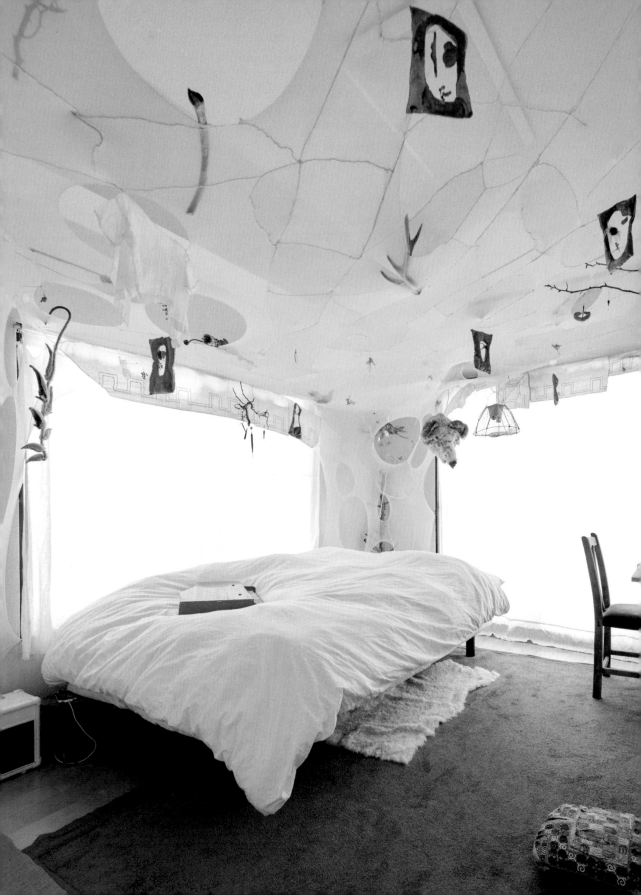

A dreamy space for weary heads

WHO LIVES HERE
Hiroshi and Haruna Ito,
their daughter, Yuri, and
housemate Noriko Amano

LOCATION
Tokyo

HOUSE SIZE
3 bedrooms, 1 bathroom

WORKING LIFE
Hiroshi is an art curator; Haruna
is a food designer; Noriko assists
in a gallery.

OF PARTICULAR INTEREST
One of the bedrooms is an
art installation.

Japanese art is widely appreciated for pushing the boundaries. Those boundaries sometimes include making entire bedrooms an art installation, as has been done in a share house near Shinjuku.

Hiroshi, his wife, Haruna, and their baby, Yuri, live in one bedroom, Noriko lives in the second bedroom and the third bedroom is open to guests and art aficionados to come and rest their heads. Yumi Arai is the artist behind the installation and has created a dreamy atmosphere to escape to.

Hiroshi, Haruna, Noriko and Yumi all met through their love of art.

Noriko moved in with the couple and their baby and lives on the top floor, sharing the bathroom, kitchen and living room with his housemates. 'Everyone works in social design and art, so we have similar interests,' says Noriko. 'No one is stressed in the house – we each keep our own pace and respect each other's space.'

Hiroshi and Haruna had no trouble deciding to share their house with Noriko, despite having a little one. 'It's important [for Yuri] to meet another adult and not only our own family I think,' says Hiroshi.

With the third bedroom vacant, Hiroshi wanted to bring art into their home and approached Yumi to curate it.

'I was thinking it's sad that installations disappear every time the exhibition finishes and wanted to preserve an installation for a long time,' says Yumi.

The room took about four months to complete and has since hosted a number of guests. Yumi drew inspiration from Finnish and Japanese folklore and the sounds from the street below. 'When I entered the room, I heard some children's playing voices from the elementary school,' Yumi explains. 'Also, there is a sloped ceiling in the room. From these inspirations, I associated it with a kind of secret base and decided the concept of the room would be "maja". In Finnish, "maja" means tree house, which only children can build in the tree. When I was small, I made a secret tree house with friends and the time spent there felt never-ending and not to be disturbed by anyone.'

The sheer tights that are stretched across the room make it feel secluded, with minimal pieces of furniture that includes a writing desk, a chair and a bed. The room encourages dreams and imagination with playful touches like the children's piano and abstract hangings such as the bear head. 'The bear is a symbol of God in a forest according to the mythology of Finnish and Japanese folklore,' says Yumi. 'When I was small I had a teddy bear and shared the most time with it, like a best friend or alter ego. The bear is the most important animal that connects with memories of childhood for me.'

Yumi is a regular visitor to the house and all the housemates connect through their love of art. 'We like to share books and talk about good exhibitions because all of us like art and culture,' says Haruna. Sitting down at the dining table next to the kitchen with Noriko's gyoza or Hiroshi's *nabe* (a Japanese hot pot dish) is where they come together to share their artistic aspirations with one another and hopefully dream up their next beguiling exhibition.

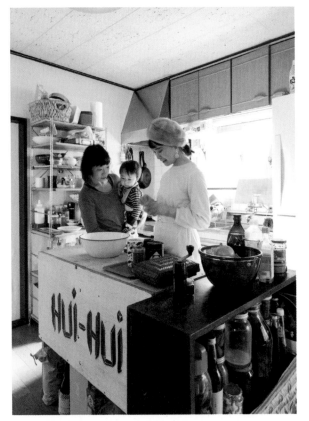

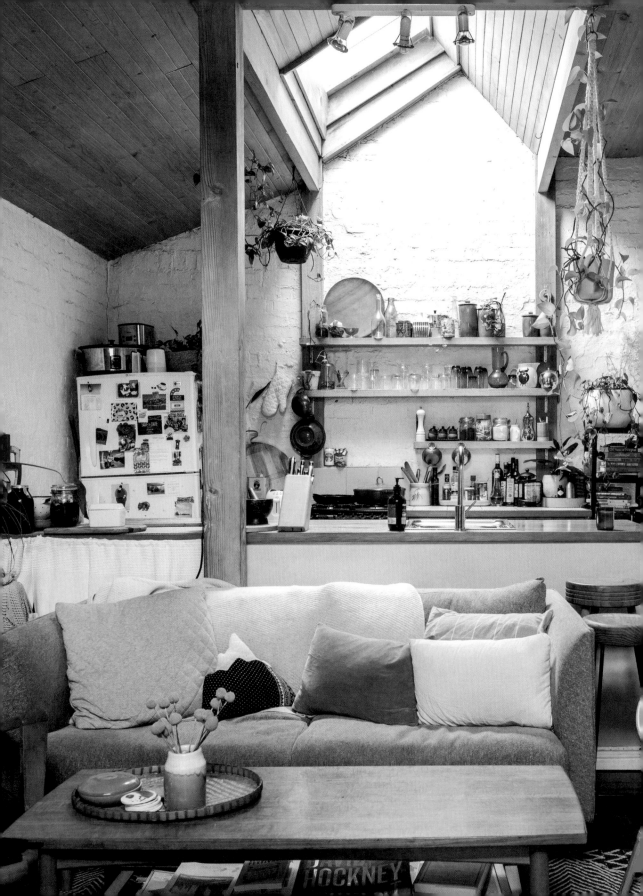

Two set decorators bring work home

WHO LIVES HERE
Courtney Webb and
Maddy Worthington

LOCATION
Melbourne

HOUSE SIZE
2 bedrooms, 1 bathroom

WORKING LIFE
Courtney is a freelance set decorator
and pilates instructor; Maddy is
a freelance set decorator.

OF PARTICULAR INTEREST
When Courtney was cleaning up
the back courtyard she found an iron
metal sign saying 'COURT'. This house
was obviously meant for her.

Being a set decorator often means you're lucky enough to have dibs on some of the coolest furniture and decor in town. It's also the perfect job for share housers or those on a decorating budget because as soon as shooting wraps, the props are often free for the taking.

In this share house in Carlton, in inner-city Melbourne, there's not just one set decorator living here, but two! Housemates Courtney and Maddy have both worked on major TV and film sets across Melbourne and, as a result, have been able to kit out their home with some absolute decorating gems.

'You have to become very critical about what you actually bring home, because otherwise there's just too much stuff in the house,' says Courtney.

'Exactly,' adds Maddy. 'You need to ask yourself, "Will I ever find something like this again?" If you don't think you will, that's when you bring it home.'

Maddy and Courtney have been living together for four years. Maddy was living in the house prior to Courtney moving in and had taken on the lease from one of her friends. 'We were really lucky. It's one of those rentals that has been passed on from one group of friends to the next and we just deal directly with the landlord. There's no real estate agent involved,' says Maddy.

The two-bedroom house is not big by any means. However, it is the perfect size for two. The open-plan living space boasts high timbered, panelled ceilings and skylights, which is quite rare

TIP:

Avoid clutter by decorating your home with pieces you can see yourself holding onto forever.

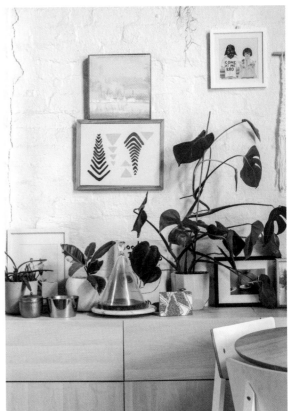

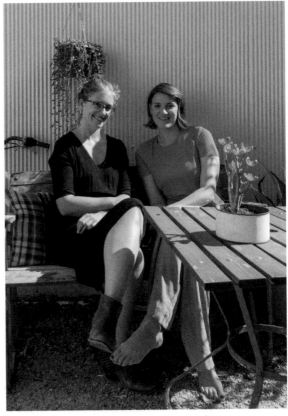

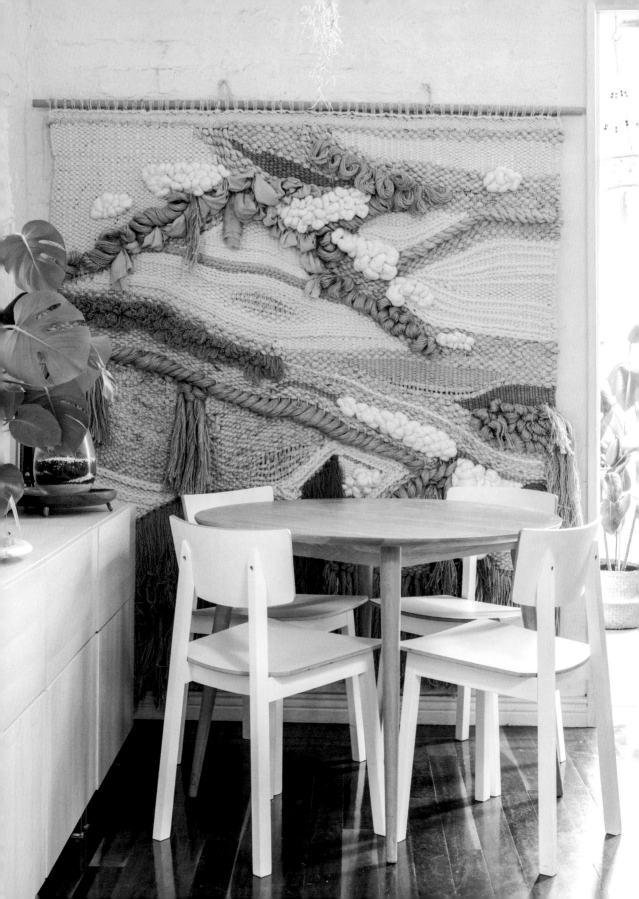

for a traditional Victorian terrace. All the furniture and displayed knick-knacks have been curated for the space, which Courtney and Maddy often move around to create a fresh feel.

Merging styles for these two isn't very difficult, as they both have similar tastes and a real affinity for interior design. They also enjoy sharing new pieces and styling ideas with each other.

'I think that if there's a piece your housemate has brought in that you just can't stand and it won't work with styling tricks, you should ask them nicely if it can live elsewhere,' says Courtney.

Beautiful artwork and wall hangings decorate this house, including impressive weavings by Courtney who co-owns a weaving company called Warped Threads.

She can often be found in the living room threading a new masterpiece. Maddy also contributes to the wall decor with her collection of photography and artwork from friends, both Australia- and UK-based (where she's originally from). Open shelving displays some of their unique glassware and crockery collections, which have built up over the years.

Both Maddy and Courtney work on and off projects and, as freelancers, their schedules can vary, but they try to come together as often as possible for some TV and a glass of wine. Whether it's the *The Bachelor* or watching a documentary, it's the best way to relax on a night off.

Making a shared
life shine

In the kitchen

The most important thing to remember about a share house is that there are public and private areas. Knowing how to use these spaces will make the overall atmosphere of the house more positive, and giving these rooms some love through decorating will elevate your shared life to the next level. In a share house the kitchen works overtime. The fridge stocks every housemate's food for the week. The oven and stovetop cook not just one meal, but several each day and dirty dishes are always plentiful. It's important to keep an organised kitchen. Depending on how many people you share the kitchen with, there are some handy ways to make sure things run as smoothly as possible.

1. TAKE RESPONSIBILITY FOR YOUR OWN FOOD
No one likes a science experiment gone wrong in the fridge or the pantry, especially when it's a mystery who it belongs to. Make sure you do a regular stocktake of your food and keep an eye on what is going past its use-by date. Labelling is always a good idea.

2. CLAIM YOUR SPACE
It's a good idea to allocate a shelf in the fridge and pantry for each housemate. This way you're aware of what space you can fill up with grocery shopping and you know not to sort through other housemates' shelves while searching for your own food.

3. KEEP COOKING UTENSILS ON DISPLAY
Time is precious in the kitchen when your other housemates are patiently waiting on the sidelines to jump in and prepare their own meals. Keeping cooking utensils and pots and pans on display will help save time. There are hanging racks available that can be used on the splashback for utensils and others that attach to the wall for pots and pans.

4. WASH UP
Make sure you always wash up after yourself when cooking. You may want to relax and take your time over dinner, but your housemate may need the pan you've just used. If you are a good multi-tasker, try getting through the washing up as you cook.

5. STOCK UP ON THE BASICS
Crockery, glassware and cutlery – these are the things that can run out in a share house. If you and your housemates also like to entertain, it's better to get some extras of these basics.

Above all, stock up on wine glasses. They tend to get broken a lot, so it's always worth having back-ups.

6. SHARE MEALS
Sitting down for a meal with your housemates is a great way to bond and eliminates rush hour in the kitchen. Sharing recipes and a glass of vino not only makes the house feel more homely, but will put less stress on your kitchen.

7. MAKE IT PRETTY
Don't forget to put some thought into decorating your kitchen. It may seem like there's less opportunity to put a decorative stamp on this room, but adding a fun tea towel, hanging baskets for fruit, potted herbs and some colourful cooking books is often all it takes to make this shared space look inviting.

In the living room

If you're lucky, housemates will become more of an extended family than co-habitants. Being able to come home after a long day, kick back on the couch and talk through each other's struggles and triumphs will make you love home even more than you can imagine.

Share housers often have busy schedules, which makes these moments spent together that bit more special. And when they do happen, the destination of choice is usually the living room. This common space unites the household and should be a room where each member of the house feels at ease.

More than in any other common room in the house, decorating the living room together offers the best opportunity to merge style. It's a chance for everyone to express their personality through design and will make the presence of every housemate felt when looking around the room.

We're all different, so creating a space that each person feels comfortable in will vary, but here are some universal tips for decorating the shared living space that will help create a more homely atmosphere.

1. INVEST IN A QUALITY COUCH

Shared living rooms are high-traffic zones. It's where you and your housemates hang out, and where friends, families and sometimes pets come to visit. Investing in quality furniture in the living room is a good idea, especially the couch, which receives the biggest workout of any piece of furniture in a common space. Make sure it's a couch that you look forward to plonking down on after a long day.

2. ADD RUGS AND RUNNERS

Rugs will warm up the room, especially if you have hardwood floors. They also break up the different areas if you have an open-plan space. For example, rugs can make the living and dining areas feel separate.

3. ESTABLISH POCKETS OF LIGHT

Pockets of light beat the harsh glare of overhead lighting. Shaded lamps around the room will still provide ample light, but in a friendlier way (and friendlier for your power bills too).

4. KEEP THINGS TIDY

It's nice to feel the presence of housemates through the decor, but not through the mess. There's nothing worse than looking around the living room to see dirty dishes from an unnamed housemate's dinner from the night before, or feeling like you can't quite settle in to watch some TV because who knows the last time the couch got a decent clean. Making sure everyone tidies up in the living room will make it much easier to relax there.

In the bedroom

The bedroom in a share house offers more than just sleeping quarters, it's a retreat as well. You can escape there by simply closing the door to let everyone know you need some quality downtime. Watching movies in bed, meditating and reading can all be best enjoyed in your private retreat.

1. CREATE A RETREAT
It's important to make your bedroom a safe and happy place where you can while away the hours and feel completely at home. Hang photos or art on the wall, burn your favourite scented candle, and invest in some quality bed linen. It's these little things that can make you love your space.

2. REFLECT YOUR STYLE
Unlike the shared spaces, the bedroom is the one space that is completely your own and becomes a direct reflection of your style. While you may have to compromise on letting your design flair influence the communal areas, your bedroom is a canvas to experiment with. Move furniture around, play with colours and have fun with bold design choices.

In the bathroom

When there are a lot of people sharing a bathroom, it can easily get messy and clashes during shower times are a nightmare for some households. Here are tips for a happy bathroom that will function more efficiently, and look just as good as any other room in the house.

1. KNOW YOUR HOUSEMATES' ROUTINES
To avoid waiting impatiently for a shower, which can make you late for work, learn what your housemates' routines are. It could just be a matter of coordinating who showers in the morning and who showers at night.

2. KEEP IT CLEAN AND ORGANISED
Bathrooms in share houses can have a reputation for being dirty, which is ironic because it's where you go to get clean. Keep to a regular cleaning roster for the bathroom to make sure no germs are spread. If storage is an issue, buy some free-standing drawers so each housemate has somewhere to keep their things.

3. ADD COLOUR
Colourful hand towels, bath towels and floor mats can add much needed character to a plain bathroom. Shower curtains are another option to play with for that touch of fun.

4. WORK IN PLANTS
Many plants thrive in the humidity of the bathroom and can soften this hard-surfaced room. The peace lily, rhipsalis and pothos all love the moist atmosphere.

Outdoor living

Outdoor space is highly sought-after in a share house. Courtyards, balconies, rooftops, verandahs or green garden backdrops all offer additional areas for housemates to use, so it's worth putting in as much consideration when decorating the outdoors as you would when styling any other room of the house.

Plants, lights and simple furniture settings are effective ways of creating an outdoor room and reaping the benefits of fresh air and sunshine. It can be a rewarding experience as a household to see your outdoor area come to life – not to mention a great setting for entertaining.

1. DINE ALFRESCO
A table and chairs is a natural choice for outdoor living. It creates a place to dine alfresco and welcome in the warmer months of the year with housemates and friends. If your dining setting is in full sunlight, consider an umbrella or some shade cloth.

2. CREATE MOOD LIGHTING
Outdoor lighting is sometimes just made up of one giant floodlight. To make your outdoor space friendlier at night, hang some fairy lights or festoon lighting. Lanterns and candles also set a relaxing tone.

3. USE POTTED PLANTS
Don't let a bricked courtyard or concrete balcony stop you from greening up your outdoor space. Use potted plants to add a touch of nature that you can take with you when you move out. Terracotta pots offer you the perfect canvas if you want to get creative and paint some fun designs.

4. CULTIVATE YOUR GREEN THUMB
If you have a back garden, add your favourite plants to it. Whether it's a flowering plant, or a low-maintenance variety that will thrive independently, a lush garden will make spending time there more attractive.

5. BRING WALLS TO LIFE
Some courtyards and balconies can be uninspiring if bordered by tall fences or hard concrete walls, which can make a space feel closed in. For a friendlier outlook, try creating a vertical garden. Reclaimed wooden shipping pallets make a great framework and look fantastic when densely planted with succulents or perennials, or attach pots to a steel-mesh frame and fill with a variety of trailing plants or creepers.

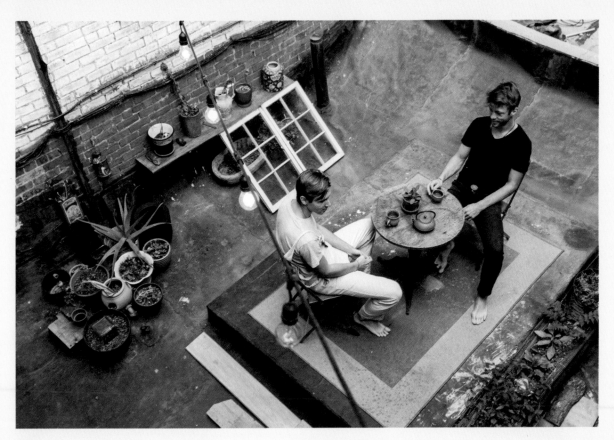

From friends to housemates

WHO LIVES HERE
Tobi Hofmann, Mia Herholz
and Lotti the dog

LOCATION
Berlin

APARTMENT SIZE
2 bedrooms, 1 bathroom

WORKING LIFE
Tobi is a high school teacher;
Mia is a freelance graphic designer
and part-time office manager.

OF PARTICULAR INTEREST
According to Mia it probably has
the prettiest ugly flooring in the
whole of Friedrichshain, but it also
has a very unusual and generous
hallway and beautiful linden trees
right outside the balcony.

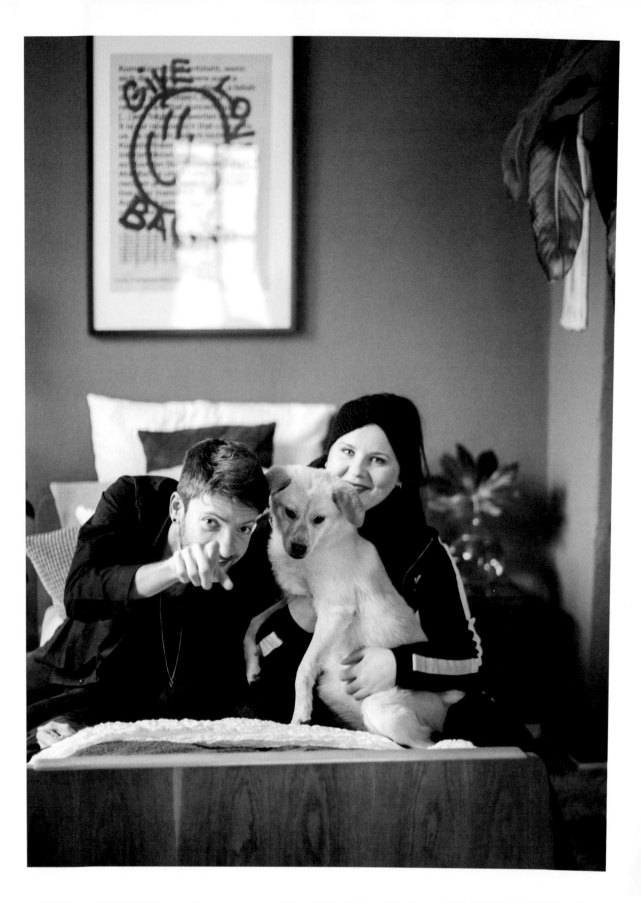

Mia and Tobi met at high school and have taken that friendship to the next level by becoming housemates. The two 20-somethings had previously lived with strangers, but decided that living with a friend was much more sensible. Their happy home has a very peaceful atmosphere, not just because they get along so well, but also because they share a similar aesthetic. Their design style mixes contemporary and vintage with vibrant colours, which complement the original older style of the home.

Moving in with a friend can be a make-or-break experience. You find out more by living together than you would ever have discovered by simply being friends. However, for Mia and Tobi, becoming housemates proved to be a great decision. 'The best part of living with Tobi is living with someone you know and appreciate; someone who understands you and feels like family – especially in such a crazy city like Berlin,' Mia says.

Tobi and Mia have combined their love of interior design to create a relaxing space that feels like home. The building in Friedrichshain is old and comes with its quirks, such as the black-and-white lino flooring in the kitchen, which the two housemates have come to love. 'Our kitchen is 50 per cent a place to hang out with friends and 50 per cent a place to prepare five-course menus,' Tobi says. The rooms boast high ceilings and details such as decorative door handles, which add a layer of character and integrity to the space.

The housemates have merged their styles seamlessly. It is clear that both of them have had fun styling the house, from painting colourful walls in their bedrooms

TIP:

Pair different styles together for a distinctive look, such as combining contemporary styling with select vintage pieces.

to combining their collections of edgy art. They enjoy showing each other new decorative pieces they have found and aren't afraid to share their opinions about what works and what doesn't in their shared spaces – communication that can only really happen when two people are completely at ease together.

Their third housemate is a bit furrier and doesn't contribute to decorating, but definitely contributes to the homely vibe of the apartment. Mia found Lottie the dog at a small German shelter and fell in love with her instantly. But she knew that it wasn't just her home she was bringing Lotti back to – it was Tobi's as well. She says that while Tobi took some convincing, he now loves Lotti and considers her a big part of their family.

'I think it's important that every housemate is fine with a pet and that there's a Plan B in case of failure. But, honestly, is there anything more relaxing than cuddling with a pet?' says Mia. Lottie has more than enough space in the apartment and even has a back garden, which is shared with their neighbours in the building.

While it can be hard to strike the balance between friend and housemate, Tobi and Mia have become closer as friends and established their own little family in Berlin.

'Of course moving in together can be a risk for the friendship, but when you are able to talk honestly to each other and know you can rely on each other, you can handle it,' says Mia. 'We have a deep friendship and also like being crazy together when nobody is looking,' says Tobi.

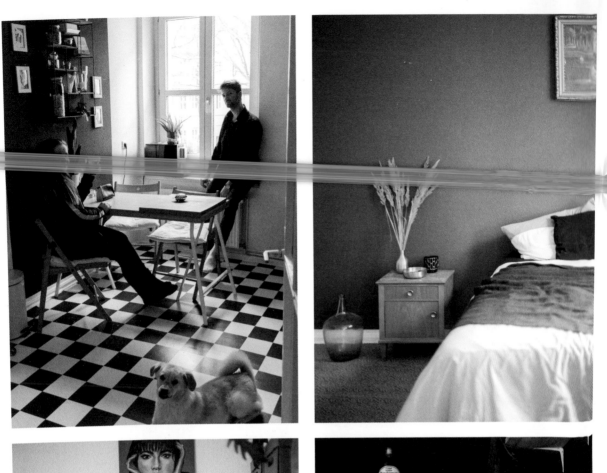

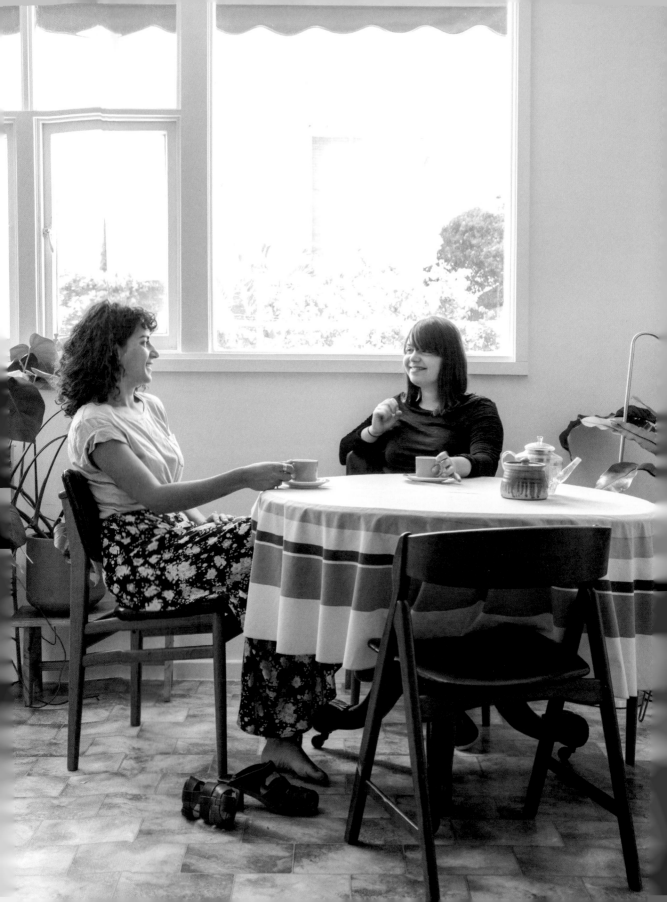

Embracing retro roots

When it comes to decorating, share housers may need to adjust their styles to suit the era of the home. Renting often means you're not living in the home of your dreams. Priorities are location, space and amenities rather than architecture.

For Octavia and Siobhan, their Edwardian-style home in Northcote has character and charm, with its high ceilings, stained glass and decorative cornices.

They aimed to complement the older interior with their styling by using wooden materials, vintage furniture, lots of plants and small curiosities. As a result, this old gal of a home suits its twenty-first century occupants down to a T.

WHO LIVES HERE
Siobhan Amad (left) and
Octavia Bryant (right)

LOCATION
Melbourne

HOUSE SIZE
2 bedrooms, 1 bathroom

WORKING LIFE
Siobhan is a baker at Dr Marty's Crumpets; and Octavia is a doctoral student in politics.

OF PARTICULAR INTEREST
There is a beautiful backyard with lots of fruit trees, including figs, lemons, apricots, and a grape vine.

How did you two meet?

Octavia: We met through a mutual friend, who introduced us while we were both on the lookout for a new share house.

Siobhan: I fell in love with the place straight away and so badly wanted to move in. We hit it off pretty quickly. Oci was tossing up between myself and another friend of hers, so I tried to sell myself by telling her about my sweet vintage record player and rad collection. Obviously worked!

What is your secret to living in harmony with each other?

Octavia: I think the secret is finding the balance between spending time together and figuring out when the other one wants space. It's sometimes a hard balance to find, but I think Von and I managed to strike it early!

Siobhan: I think it's by really taking care of the space. We try our best to make it feel like a home, not just a house. Keeping the space clean, staying on top of grocery shopping, respecting each other's quiet time when needed, but also making an effort to be social and spend quality time together. Whether it's having a vino on the porch,

cooking dinner together or binge watching a trashy series.

Why is it important to put thought into decorating a share house?

Octavia: It can be hard decorating a house while living with people who have different styles and tastes, but I think it's still really important to make the effort. After all, it's where you spend a lot of time and where you go when you want to unwind. I'm always more relaxed and happy when I'm in nice and welcoming surroundings, so I've always believed in putting effort into my decorating. If your home is decorated well you're also more likely to want to spend time there and invite people around.

Siobhan: I think it's important because we want the space to feel like a home, not just a house we are temporarily renting. By putting thought into how you decorate the space, it becomes more of your own and has more of a positive feel to it. If you love the space you're in, you take better care of it. Our house has a really calming, homely vibe, which is felt by everyone who walks in the door. We have lots of greenery/indoor plants around the house, a lot of artwork and beautiful pieces of pottery.

You live in an older home. How have you embraced its ageing features?

Octavia: I love the fact that it's a mesh of eras. The rooms are all really large, with beautiful decorations on the ceilings. The large rooms, and in particular the ceiling details, are something you just don't get with newer homes. I also love the fact that the kitchen is still old. It may not be modern, for example, we don't have a dishwasher, but it still has cute details, like the lino on the floor and the colours, which I love.

The age of the house definitely factors into how you style your home. While I also love modern homes, older homes seem to automatically have a bit more character, which is awesome. But it also means adapting your style to suit the home's personality. For our home, it meant utilising furniture that used a lot of wood, because that worked well with the age of the house. We also bought quite a modern couch for the living room, so to soften it a bit and make it suit the older style of the room, we made sure we covered it in cushions and throws.

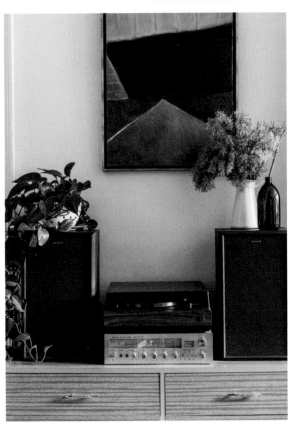

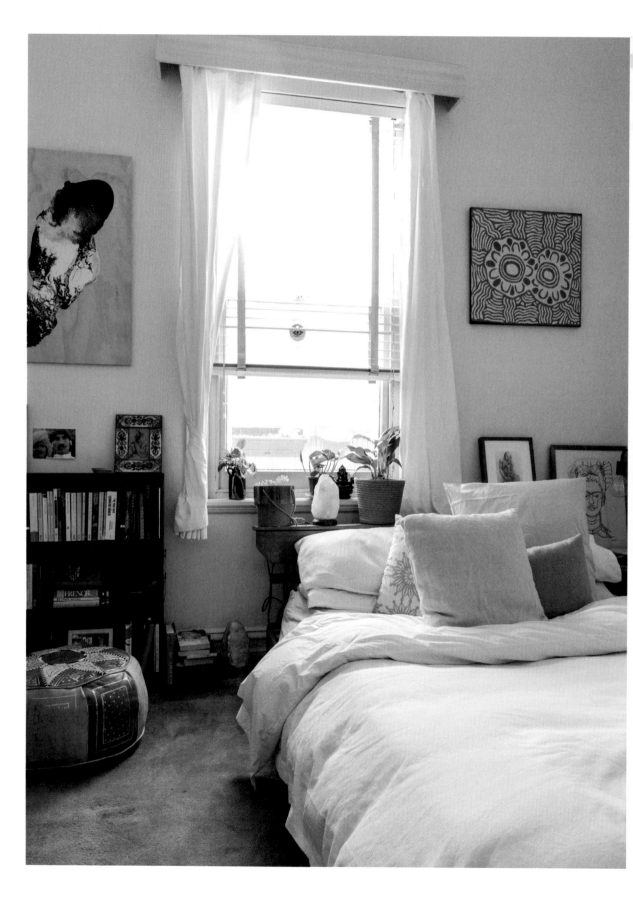

Have you learned anything about your own decorating style from living in a share house?

Octavia: I'd say that I really only developed my own sense of decorating after moving out of home and into a share house. It took a few years though. When I initially moved out as a student, it was more difficult to properly get a sense of my own style, as my funds were fairly limited. But once I'd been living out of home for a while and I began to earn a bit more, my style developed organically. It's probably also been influenced by those who I've lived with. I've realised I like to keep the decor minimalist, with a modernist twist. And lots of plants.

Siobhan: Oci has quite a minimalistic style, which I love! And before living together I probably thought that was my style also. But in comparison, I've realised that I have a bit more of an eclectic style – although I try not to go overboard. I really enjoy paintings, photographs and things hanging on the wall. I love candles, salt lamps, incense and anything that enhances the energy of a space. I like trinkets too – memorabilia and treasures collected from my travels. I guess I am a very visual person so I enjoy the visual stimulation and also the sense of nostalgia that certain items can bring you. But I try to restrain myself and keep it to a minimum because I don't like clutter.

What tips would you give share housers who are moving out for the first time?

Siobhan: No matter how busy your life is, take the time to put effort into your home. That may mean allocating half a day to clean, do washing, change your sheets, grocery shop, garden, light candles and have a bath (then clean it when you're done). Do whatever you can to make your space look and feel beautiful.

What is your favourite room in the house?

Octavia: My favourite room is the television/living room, just off the sitting area. It's really cosy and welcoming, and the perfect place to unwind. It also has beautiful art deco patterns on the ceiling, which I love. I'm also a big fan of television, so there's that.

Siobhan: I'm so in love with our sitting room. The carpet is pink and plush. The sofa is so comfortable with heaps of fluffy cushions and the room gets beautiful, golden afternoon sunlight through the window, which the plants absolutely love! We call it the Healing Room. Whenever a houseplant is looking droopy and dull we move it into the Healing Room and it flourishes! Our devil's ivy has grown about a metre in a short period of time and looks so vibrant and green.

What is your favourite piece of decor?

Octavia: I don't know if there's a standout piece per se. I think the decor is fairly subtle but works together with the plants to give the house a particular feel. That being said, I really like the dining chairs – they work well with the round dining table, which I also love.

Siobhan: My favourite piece of decor would have to be my vintage record player, which was a present from my family for my 30th birthday. It's so dreamy listening to Sam Cooke on vinyl while having a bath, or Roy Orbison while cooking dinner or Solange while having a glass of red wine with the girls.

Defying the odds

WHO LIVES HERE
Rose Agnew, Eva Dunis and
Stephen Pearcy

LOCATION
London

HOUSE SIZE
3 bedrooms, 1 bathroom

WORKING LIFE
Rose works in digital innovation
and is studying her masters at
Hyper Island to further her digital
knowledge; Eva is an embroidery
and jewellery designer; Stephen is
an architectural assistant.

OF PARTICULAR INTEREST
Rose is actually Eva and
Stephen's landlord.

London is commonly associated with dark, dreary weather. However, there's a share house in Hackney that proves London light can pour into a home in the city – if you let it.

Rose, Eva and Stephen live in Hackney, an area that has attracted creatives of all types who can't resist the warehouse vibe and hole-in-the-wall cafes. Rose owns the house and Stephen and Eva rent the other two rooms from her.

Rose and Stephen met at an 18th birthday party and remained friends, so when a room came up in Rose's newly purchased house, she called him. Eva applied to be the third housemate through a Facebook group after moving to London from France to pursue her career in embroidery and jewellery design. The three of them are all very different, both in personality and style, but have a real appreciation of each other.

'Steve is such a calming presence – the opposite of me. He's very dedicated to his work, which is inspiring. Eva has the most amazing style. The Frenchies always amaze me at how much effort they put into chopping food so perfectly. You should see Eva's lunchboxes,' says Rose.

Rose led the way in terms of styling the house. As the owner, she felt it was her responsibility to make sure the home was furnished and cosy for her housemates, not to mention excited by the prospect of finally having her own digs to customise. Being the principal decorator in a share house has taught her many things. One of the most important lessons has meant the adoption of a more relaxed attitude. 'I'm far too perfectionist, but you have to chill and let people use the space as it's their home! Sometimes it's difficult when someone else has very different taste to you,' she says.

The living room style is contemporary with key pieces of furniture taking the limelight. The leather couch is Eva's favourite piece, and

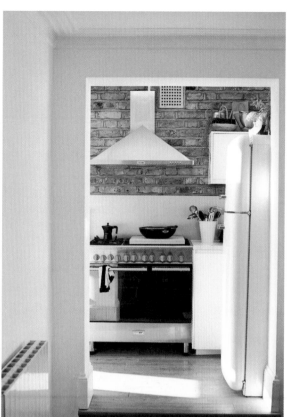
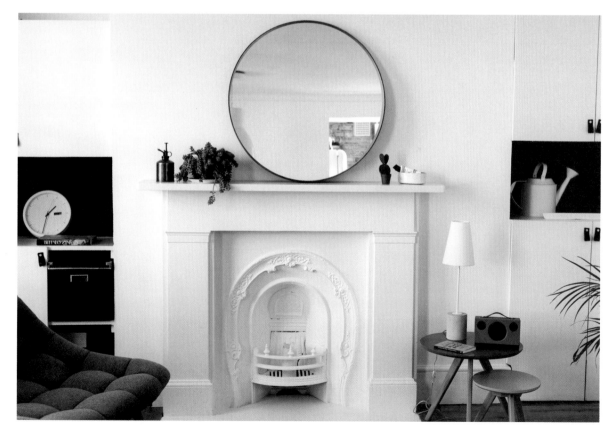

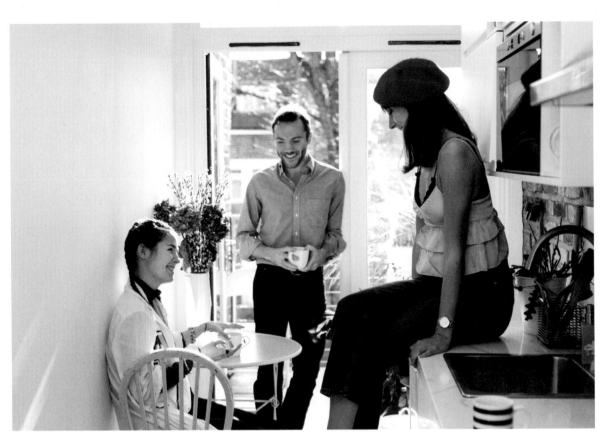

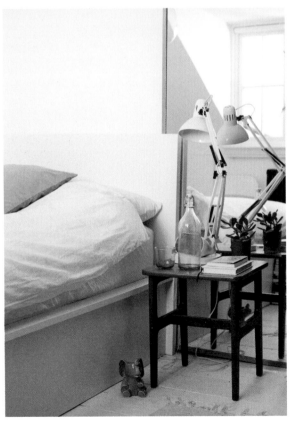

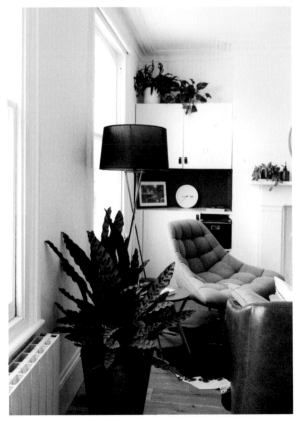

Stephen particularly likes a grey upholstered chair, which he says is great for practising the lotus yoga pose. Rose admits that she ran out of money before she could decorate the rest of the home but says as soon as she gets her dream job, she will be splurging on a tonne of artwork and a runner for the staircase. Meanwhile, the uncluttered design works to their advantage, as it means that light flows through the rooms quite naturally and creates a feeling of space.

Rose's style is contemporary and pared back. Stephen admits that he has not really got an eye for design, which is why he was pleased Rose took charge as principal stylist.

'Eva once nagged me that I need to buy more stuff to fill my empty shelves. However, I believe that joy comes not through possession or ownership but through a wise and loving heart,' he says.

Eva loves pops of colour and lets that come out in her bedroom. But she also has an appreciation of alternative design, which she finds gives her a new outlook.

The kitchen is a place to congregate in this share house, as each of the housemates enjoys cooking and spending time in the sun-drenched room. Although it's a small space with a galley-style kitchen, it's highly functional and they all produce amazing meals in it. Rose likes to try to replicate dishes she has sampled during her travels to Bali and Sri Lanka. Stephen enjoys cooking anything with mushrooms in it and Eva prefers a traditional methi dal.

The three of them often get their ingredients from the local greengrocer at the end of their street, which has everything from fresh turmeric to jackfruit, and kumquats to Jerusalem artichokes. All of this is stored in the Smeg fridge Rose splashed out and bought and is now one of the main design features of the kitchen.

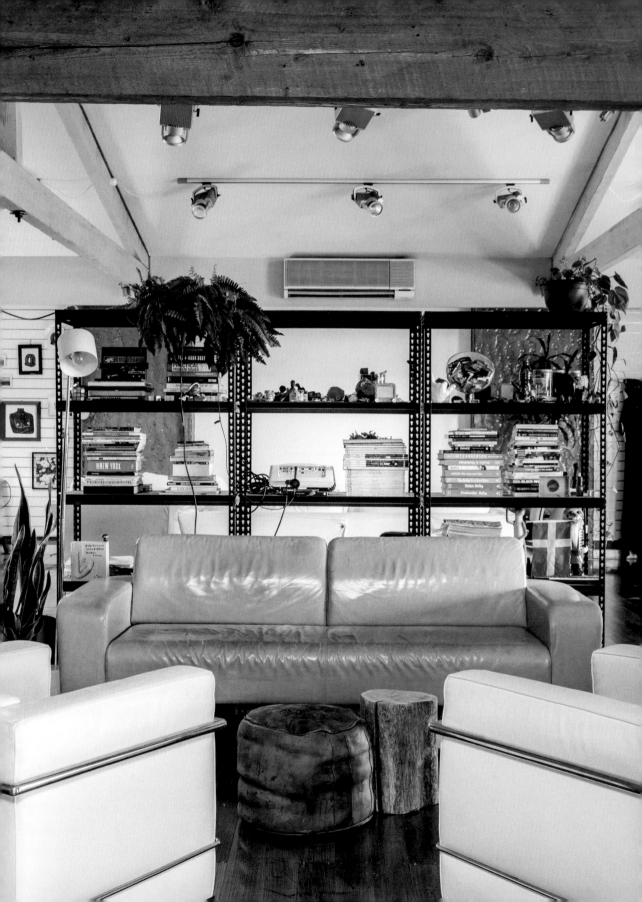

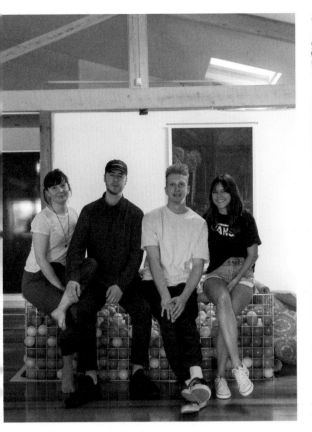

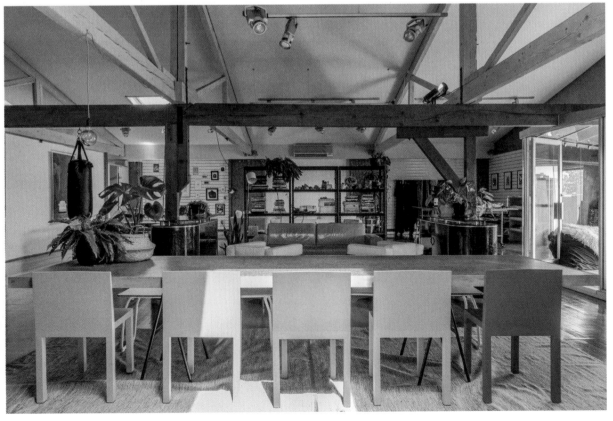

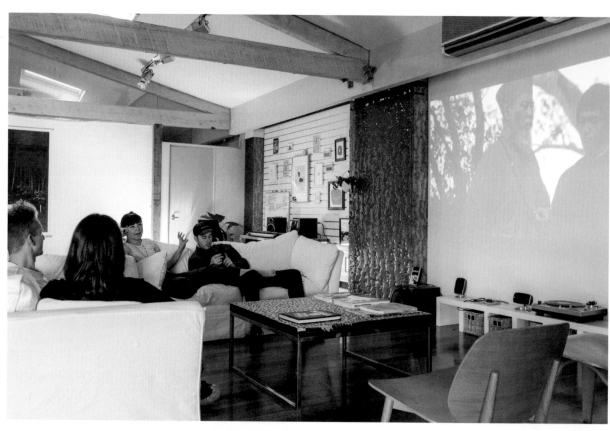

found out we got the apartment on the same weekend. So I took down retail racks from the wall and tied them together to make a cage and it worked out perfectly!' says Olivia.

The apartment has a huge open-plan space, which is both a blessing and a curse for decorators. The challenge was to take away the feeling of it being a big empty office space and turn it into a welcoming home on a budget.

One of the ways the housemates did this was by custom-making furniture in a larger size and using pieces that take up more space. Jai made the dining table out of plywood, which he bought from the local hardware store. He found that some of the skills he learned as a panel beater helped in its construction. Other pieces like the ball pit, Olivia's workbenches and even the punching bag hanging from the wall also help fill the area.

The large room is used for the majority of their living and so it was important to create different pockets so that entertaining, working and eating all felt separate. Industrial-style shelving helps to divide the room – particularly between the kitchen/dining room and the living and work space. By facing the couches away from the rest of the living space towards the wall, the housemates have created more intimacy. As each of them is on a budget, most of their furniture comes from hard rubbish collections, upcycled pieces and hand-me-downs.

All of the housemates are also able to work from here, with each having their own space. In one

TIP:

You don't need to be a professional to create your own personalised pieces. Upcycling materials and free online tutorials mean that anyone can furnish on a budget.

corner, Jai runs Pod and Parcel, which sells biodegradable and compostable Nespresso coffee pods using speciality grade coffee, while Michael mixes music from his computer at the far end of the apartment. Jump to the other side and you'll find Olivia fine-tuning her jewellery range and Lauren doing some marketing for Marionette Liqueurs, which designs cocktail cabinet staples.

'We all like to play around with different things and create, so having the luxury of a space like this to do that in is amazing!' says Jai.

The couples come together to chill out on the couch with a movie on the projector and some beers. They opted for a projector over a TV because it gives them a greater choice of what to watch, and with such a big space it made more sense. It's also good to have on in the background during parties.

They all agree that living together as two couples is great as they're all in similar stages in life, rather than living with a single housemate who might bring home a different person every night.

'It's really easy,' says Lauren. 'We give each other space when we need it. But we're happy to hang out when we want to catch up on what we're all up to.'

So far, they have lived in this house of fun for two and a half years, which Jai says will hopefully be forever. 'We have the best rental in Collingwood, if not Melbourne. We are very lucky to live here and I never want to move!'

TIP:
Think outside the box when decorating. Don't be scared to include elements not usually found in the typical home.

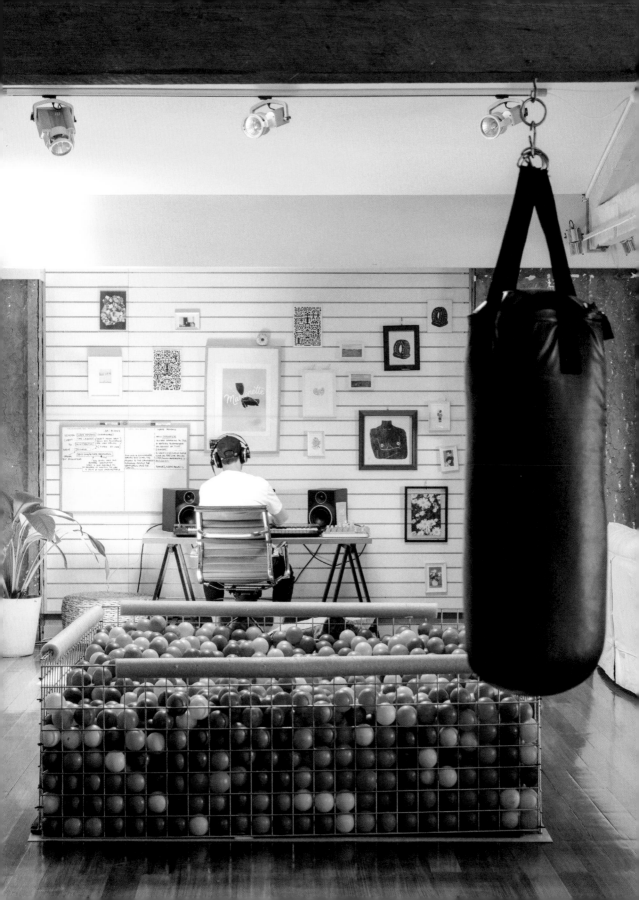

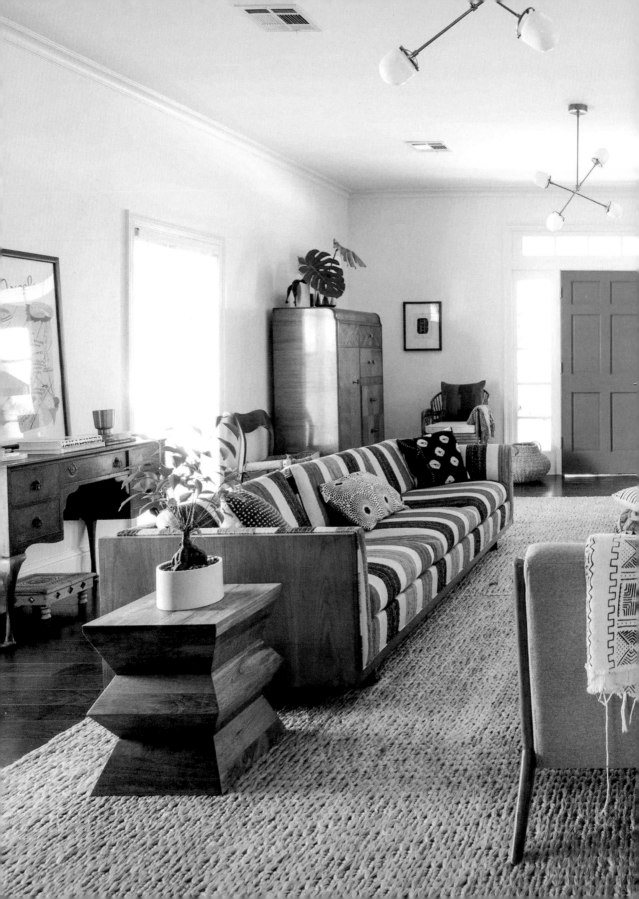

Ask the professionals

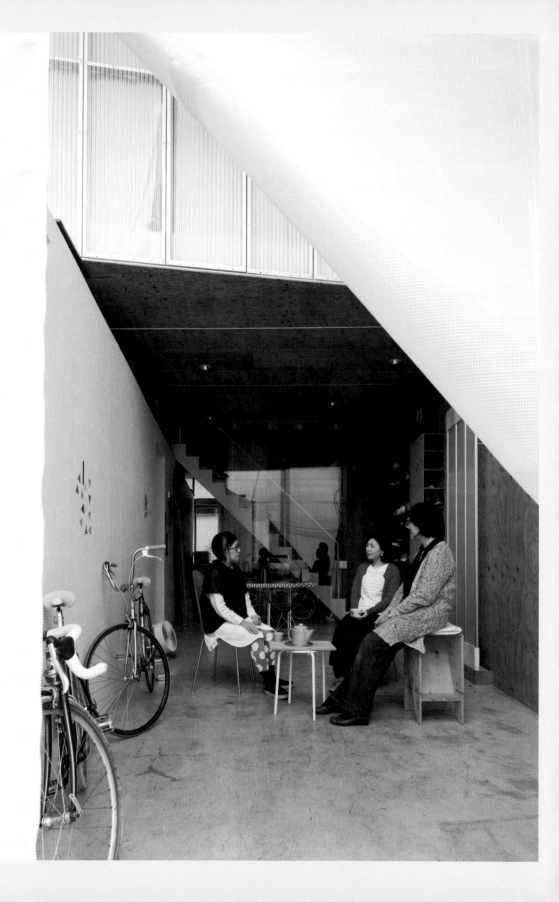

Ayano Uchimura and Satoko Shinohara

SHAREyaraicho architects

SHAREyaraicho in Shinjuku, Tokyo, is an example of what the future of share housing could look like in our major cities. What's really exciting about this project by designers Satoko Shinohara and Ayano Uchimura is that it was purpose built for sharing.

It was designed and constructed in the aftermath of the devastating earthquake that rocked Japan in March 2011. The two designers worked hard to achieve something that encouraged functional living and community engagement. Satoko and Ayano had not previously worked on a share house, but knew the concept was becoming more and more popular in Tokyo and that this design would be cheaper than the apartment development the owner had in mind. Usually, share houses in the city were converted family homes. Not many architects were creating from the ground up.

The finished result is a design that promotes social gatherings with the other housemates and the wider community. Ayano believes so much in SHAREyaraicho that she lives there herself with the six other housemates, most of them designers as well.

Tell me a bit about share housing as a design idea.

Satoko: In recent years, shared living has become popular. Many people live alone in big cities such as Tokyo. They lived in apartments – so called 'one-room mansions' – until recently. These were smaller than 20 square metres, but included all facilities like toilet/bathrooms and kitchenettes.

These small apartments had a high degree of privacy. However, the youth have come to prefer shared living. They do not have big families, or neighbourhood communities. In Japan, the size of households has shrunk, and family and neighbourhood relationships have become less important.

How did the SHAREyaraicho project come about for you?

Satoko: At first, I planned a common apartment complex, not shared living. However, from my rough estimate, I realised that construction costs would be very high. At that time, costs of construction had risen suddenly due to the upswing in the economy in Japan.

I proposed shared living to the owner of this project, because it would save money and shared living had become popular. There was some shared living in Tokyo, but these had been created from detached family houses or from company dormitories. So I suggested a new building design specifically for shared living.

How did you come up with the design for SHAREyaraicho?

Satoko: The height of this building was decided by the building code of this area. Small box-like structures span over three levels, which make up the bedrooms. Between the boxes, there are gaps of 60 centimetres, which helps to create privacy between the tenants. And there are some common spaces here, but these are extensions of these gaps. Through this connecting common space, residents feel the overall scale of this building, wherever they are.

I think the facade and the ground floor of buildings are very important, because buildings face outside, neighbours and society

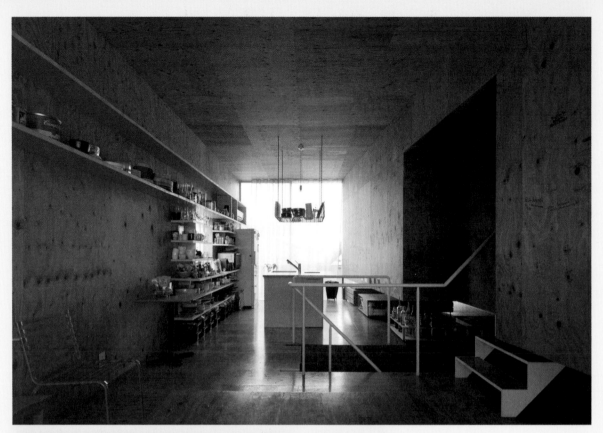

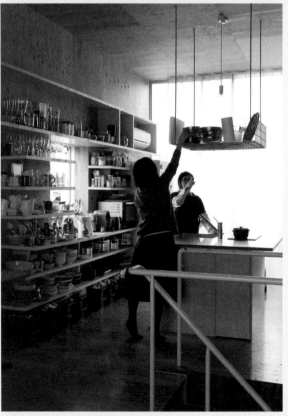

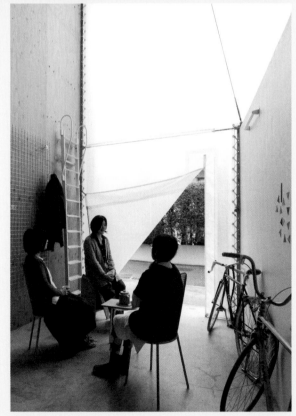

through the facade and the ground floor.

I planned this entrance hall, with a plastic membrane with a zipper, as an accessible space from outside which invites and unites. I wanted this space to be more open to neighbours and friends. Each bedroom has a key and there is a glass lockable door through the zipper membrane, but I've never seen this being used. The residents use a sign-in system to show who is in and out of the house, so that the last person out of the house knows to lock the membrane with a padlock. Each bedroom is lockable as well.

Every two months, a resident holds a talk on urban design in the entrance hall. And this space was used for the Halloween party for children living in the neighbourhood last year. At the time of such events, people sometimes open the zipper and increase the space, connecting outside and inside.

What are some of the main materials you used in the design and why did you choose these?

Satoko: I chose industrial materials like plywood, and I used these materials without any treatment as much as possible.

One of the reasons was to cut costs. Also, it is easy to get residents involved in finishing such interior materials. For example, they can decorate it with wall hangings and many of them have also signed the walls. I thought that the design of this house was made successful though the cooperation of the residents.

Tell me about the common areas and how they function for shared living.

Satoko: The common kitchen and living area are used for everyday living by the residents but sometimes friends of residents join in for social events like Christmas parties. At the large entrance hall, the larger and more open social events are held.

How many tenants does SHAREyaraicho have?

Satoko: There are seven bedrooms for residents and one bedroom for guests. In addition, there are two toilets, one shower room, and one bath. The residents share these facilities.

Who manages the property?

Satoko: Basically, residents manage it by themselves. Sometimes I join their meetings about maintenance of spaces.

What are you most proud of with this project?

Satoko: The residents who are living in SHAREyaraicho are unique. In other words, this architecture was able to attract these unique residents. They use this house well, for instance, customising gap spaces for storage, or holding a talking event in the entrance hall. They seem to enjoy life here.

Do you think shared living in Tokyo will continue to evolve?

Satoko: I think so, because the number of single dwellers is increasing. Some of them prefer shared living to apartments with high privacy without any common spaces. However, most buildings for shared living are for young people, although single dwellers are from many generations, including elderly people. Therefore, we need more variety in shared living.

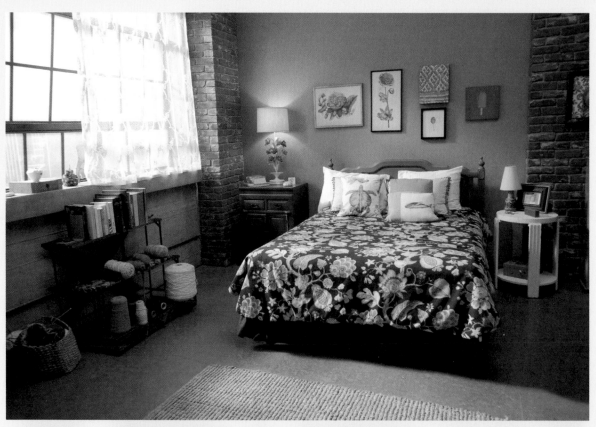

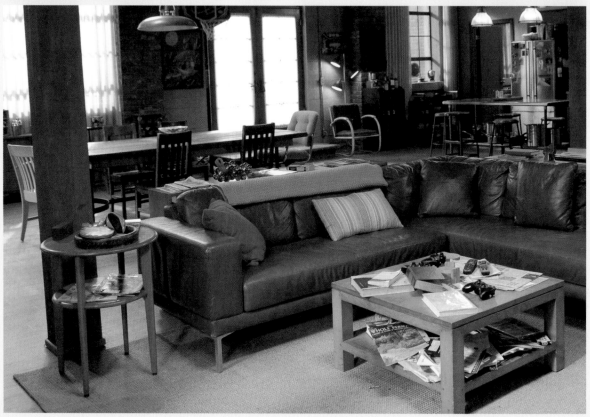

Jane Shirkes

set decorator

Jane Shirkes was the set decorator for the hit TV show *New Girl* and worked with Michael Whetstone to create the perfect share house for the show's characters. Jane was tasked with creating a shared space that accurately portrayed the home of an eclectic mix of 30-somethings trying to get by in LA.

How did you become the set decorator?

I was hired as a set decorator for the first season of *New Girl* by production designer Michael Whetstone. We work collaboratively as designer and decorator. We worked on all the seasons of *New Girl* together to the final season, Season 7. It has been a great run.

What did decorating the shared loft entail?

New Girl had started as a pilot, so when we started there was actually a set already built – the shared loft space and all the bedrooms, hallway and bathroom. I had to procure all the furniture and furnishings. Everything for the loft and all the bedrooms was purchased. Some items were manufactured, others were bought from various shops and artists.

What was the brief?

Our creator Liz Meriweather wanted the loft to look as though everything was found at thrift shops or on the street. Nothing was to pop out as though it was important or expensive. Liz was very involved in the overall look.

How do the bedrooms reflect the characters?

Nick's bedroom is very messy and dishevelled – bed on cinder blocks, desk on A-frames, fabric pinned for window curtains, no semblance of order.

Schmidt is a high achiever. He is very meticulous and his room is well designed.

Jess is very creative and her room reflects her personality – a quirky, crafty, vintage look. Her room is my favourite. One side of her bed covering has a dark background with brightly coloured flowers and the underside is vintage fabric. I made her shams from ticking fabric and paired it with rickrack and pompoms.

Winston had been a basketball player, so his room is filled with his memorabilia.

What was your own shared living experience like?

I have not lived with roommates for a very long time. When I got divorced I had a roommate who had received all this antique furniture from her grandmother in Iowa. I appreciated it, but it was not my look. I created my own space in my bedroom. I have always made things so I had my own studio within my bedroom. It was a very large room.

What tips can you pass on to other share housers?

I personally love the eclectic look. Find what you love, what you are attracted to. You can always change the colour of a wall or piece of furniture or get a new lampshade. Look at the shapes and textures of things. Move things around until you feel comfortable.

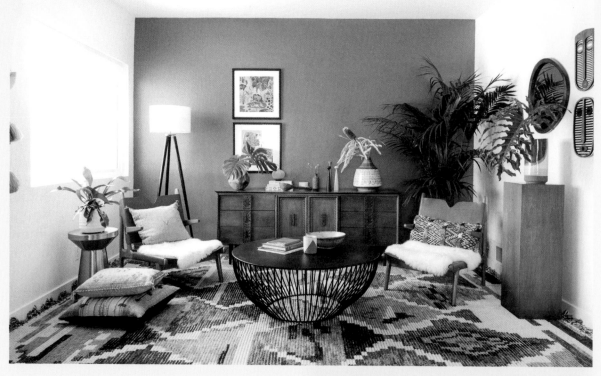

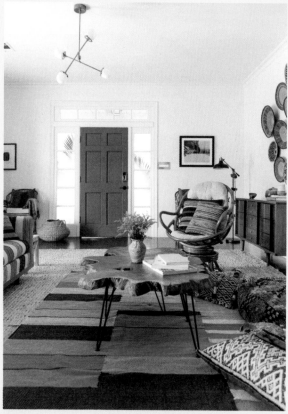

Dabito

interior designer

Dabito has a knack for designing a room that makes you smile. His style includes a feast of colours, textures and small curios that invite you to delve in and immerse yourself in the space. His blog, *Old Brand New*, details his design journeys and offers useful tutorials. He boasts an impressive following on Instagram, with detailed shots of rooms that will inspire anyone who wants to make a statement in their own home.

Describe your current home and who you live with.

I live with my partner and two lovely pups.

Tell me about your past share-house experiences.

Living with anyone, whether they're friends, roommates or partners, can be tricky. The great thing about sharing a house is that it really helps with rent. Thankfully, I've had good experiences. It's nice to share a space with someone so I never felt lonely. I had someone to cook, drink and talk with. It's also helpful when you need someone to help change light fixtures or move furniture around. The bad is when you just want alone time. I've had experiences when I had a rough day at work and the last thing I want is to deal with a housemate's bad day as well. It's difficult if someone has different cleanliness standards or if they don't pick up after themselves.

How would you describe your current style?

My style is vibrant and eclectic with modern bohemian vibes.

How did your style evolve into what it is today?

I treat my home like a canvas where I constantly decorate, paint, repaint and move pieces around. My style is inspired from my travels.

How has living in a share house influenced your style?

You get to learn about other people's aesthetic and figure out a way to merge your own style with theirs.

What pieces have you collected that are very dear to you?

I love all the pompom tassels I stumbled upon in Peru and the woven baskets from my trip to South Africa. I also love this one piece of fibre art I found at a thrift store.

What advice would you give to other share housers when it comes to decorating?

Have fun decorating together! Start with a neutral base and layer in pieces that speak to everyone in the house.

What is one piece of furniture or decor a share house can't be without?

A good, comfy sofa!

Do you think living
in a share house is an
important experience
in life?

I think it's a valuable experience.
You learn a lot about other
people's style and preferences.
It's like living with a client. And
you also learn about yourself.

If you and your
housemate have very
different styles, what
is a way you can
merge them?

Creating a gallery wall using
artworks from all the housemates.
I feel like that's a great way to
create something together that
reflects everyone's style.

What is a simple
decorating trick any
amateur share house
decorator could use to
spruce up a communal
space in their house?

Add plants to communal spaces
because who doesn't love plants?

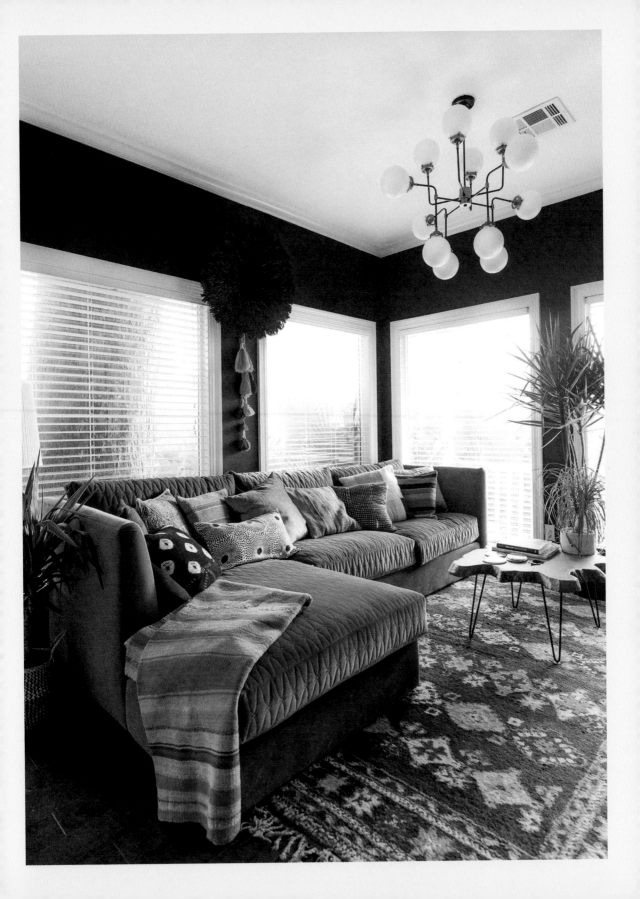

Two free spirits join forces

WHO LIVES HERE
Nica Codeiro (left) and
Lola Toscano (right)

LOCATION
Berlin

APARTMENT SIZE
3 bedrooms, 1 bathroom

WORKING LIFE
Lola is a visual artist and furniture
designer; Nica is a fashion stylist.

OF PARTICULAR INTEREST
The apartment is in an old building
with high ceilings and a very good
location close to the Berlin nightlife.

Just like two lovebirds find each other, sometimes fate steps in and brings two housemates together. It's as though Lola and Nica were destined to become housemates. They had both moved to Berlin from Brazil at around the same time and met at German language school. They hit it off immediately, sharing similar goals and laidback vibes, and soon after meeting they decided to become housemates.

Lola founded Hedoné Berlin, which Nica helps coordinate. It's an artistic movement celebrating the joys and pleasures of the body, spirit and mind. They travel the world holding parties, workshops and performances to shine a light on hedonism and, in the process, attempt to deconstruct the misconceptions that often surround it.

'We are rooted in the philosophy of ethical hedonism, which encourages experiencing and sharing pleasure without harming yourself or anyone else,' Lola explains. 'Through art, activism, education and celebration, we raise awareness and spark action on behalf of organisations fighting crimes against pleasure.'

The apartment they share shows off the luxurious amount of space many Berlin abodes can have, and the two creatives have used their ethnic and vintage styles to decorate. 'We have a pretty similar decorating and dressing style so to merge them was not difficult at all. It happened very organically,' says Nica.

It's always fun to see a housemate's fashion flow so easily into their decor, which is the case with Lola and Nica. Their eye for colourful vintage clothes translates to how they've decorated their home. Berlin is a hotspot for vintage and Nica uses her talent for good finds to run Bo Couture. 'It's a trunk of vintage finds – a mix of ethnic pieces I pick up on my travels around the world and from the

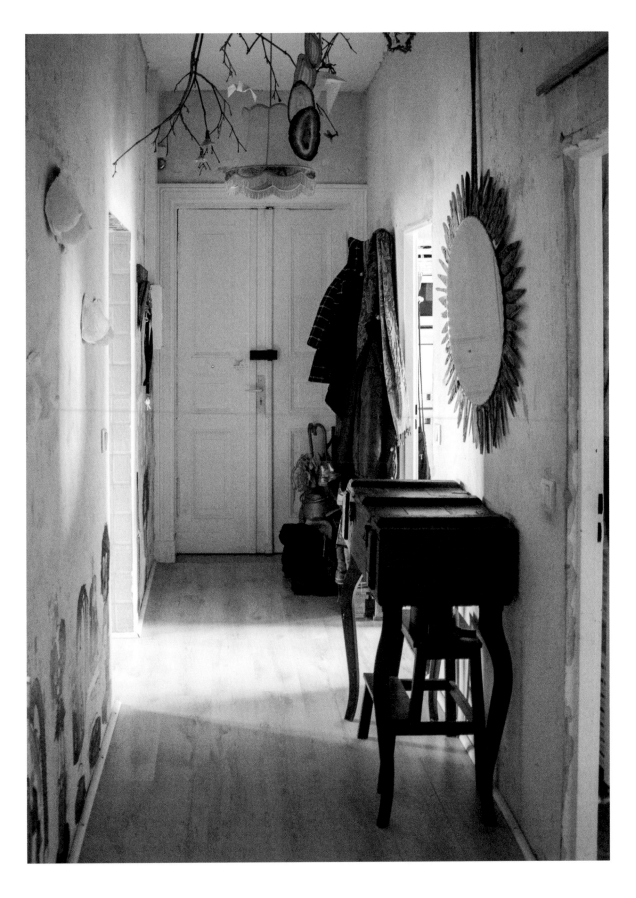

flea market down the street. The idea behind it is to create value and appreciation for what already exists,' she says.

This concept of appreciation for objects that already exist can be seen in second-hand pieces of decor, like a green velvet couch in Nica's room, mismatched chairs throughout the apartment, gallery walls with collected pieces in old ornate frames and draping pendant lights. Nica also brings back pieces from her travels to decorate the house. She made the curtains in her room with fabric she got in Kashmir, India.

Lola is a visual artist and furniture designer through her brand, Rubò, which she runs with her right-hand man Javier. She has made most of the pieces in their home. A sideboard in the hallway, a green art window in her bedroom and a half-bath chair in the guest bedroom, which both she and Nica particularly love, are all Lola's work. 'It is difficult to pick just one favourite piece. I've made

most of them so they're all my babies, but the bathtub chair is special,' says Lola.

Upcycling older pieces of furniture is something that Lola says she has learned to do while living in Berlin, and she is now able to see potential in so many things people toss away as trash.

Both Nica and Lola say the best part about living here is their bond. 'We complement each other quite well. We are not only housemates, we are like sisters and also business partners,' says Lola. When it comes to living in harmony with a housemate, Lola believes that it's always important to remember the positives about that person. 'When your housemate does something you don't like, try to think of the things she does that you do like. I try to do this always before I start complaining. If there is nothing positive to think about your housemate, then find a new one.'

TIP:

Let your personality shine in your decorating. Surround yourself with colours that make your space feel like home.

Dreaming in an LA studio

Danny and Jamee are friends and roommates who show us what it really means to share, by living together in a 1920s studio in Koreatown in Los Angeles. These two roommates share not only a bedroom, but also all the fears, joys and struggles 20-somethings go through.

They make it work by each claiming defined corners of the room – Jamee's side is Boho-chic whereas Danny's is more minimalist/Scandi. Their home serves as a safe haven as they navigate their way through the ever-changing city that is LA.

WHO LIVES HERE
Danny Hernandez and Jamee Jones

LOCATION
Los Angeles

APARTMENT SIZE
1 bedroom, 1 bathroom

WORKING LIFE
Danny is a photographer;
Jamee works in sales and retail.

OF PARTICULAR INTEREST
Both roommates share a love of the 1960s disco queen, Donna Summer.

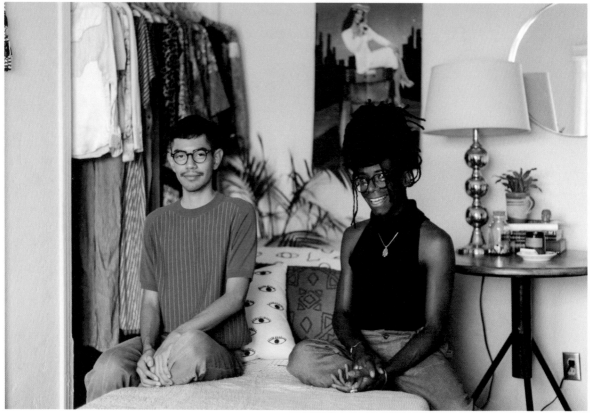

How do you know your housemate?

Danny: We met through a mutual friend while he was visiting.

Jamee: We connected over our love for disco and Donna Summer.

How did you come across your current share house?

Danny: I was photographing a couple who lived in the building. They mentioned the landlord was trying to fill a room and I felt open to change. Jamee had just moved down from San Francisco, so it was the right time for both of us. We immediately saw potential and didn't bother to look elsewhere.

Jamee: Friends of Danny had mentioned a vacancy in the building and since we were both looking for a place at the time, we decided to check the space out. Immediately we loved it for the location and spectacular view of the Hollywood sign from the kitchen window. It was an easy yes. Done, done and done.

How has your life changed since moving into your share house?

Danny: In the short amount of time since I moved to Koreatown my life has changed drastically, learning to support, encourage and heal myself. Lucky for me my family doesn't live too far away, so there's still that familiar comfort. Several years ago I was living in New York pursuing photography and here in Los Angeles I'm still doing the same. Recently, it has become apparent that Los Angeles is everything to me. The city is going through a rebirth at the moment, and as a native I see it as my responsibility to be here for it. So for now I'm just doing the best I can. I listen to soul and disco, walk the streets in the evening, I revisit my childhood places, read books in parks and I just feel right.

Jamee: I've been in LA for eight months now and I didn't think I would love it as much as I have come to love it. The moments that are most significant are the ones when I stop to appreciate the beauty of the palm trees that often line countless streets here in the city. The sight is simple but never old because it's a reminder of how far I've come.

What is it like to share a room?

Jamee: Sharing a room has its opportunities and challenges. But any challenges I feel can be easily resolved with communication. Come up with ground rules and discuss things like space and privacy. I keep busy and have such an active schedule that I'm rarely home. Beyond that, I'm respectful, clean and responsible. I expect others to be the same.

Danny: I've had housemates before, but never a shared room. This is the first time I've shared a space so personally, but privacy and space seem to function with a natural ebb and flow in our place. Sometimes I'll give a heads up about company, but I think we both enjoy an open policy that anyone is welcome at home. Life keeps us pretty wrapped up – too much to care about boundaries. We have respect for each other's moods and we know when to give breath to a situation.

What do you like about shared living?

Danny: There's a peace in knowing that the struggle in progress is not singular. There are days one of us may be down or up and it's a reminder that we're all just doing our best. I think if

Bottom photo. Left to right: Danny Hernandez and Jamee Jones

I lived alone I would start to get in my head.

Jamee: I like being able to connect and share experiences and stories of adulthood with another 20-something. It's comforting knowing you're in it together.

How did you merge decorating styles?

Danny: We both naturally claimed corners of the apartment. If something humours us, we do it. It was fun for us to come together visually and distinguish our personalities. I would say the apartment is a pretty evenly split in styles.

Jamee: I'm a maximalist so I feel like I kind of just took over naturally since I have so much junk and keep acquiring more through my thrift hunts.

How long has it taken to decorate the house?

Danny: The finished result was a few hours of chaotic scramble but in all honesty it's been slowly evolving since day one.

Jamee: We whipped up the space together collectively and, just recently, I added more decorative pieces to make it feel more lived in.

How would you describe your decorating style?

Danny: I gravitate to a sterile room with solid colours, nostalgic trinkets and baby cacti. I love wood and the contrast of synthetic materials like glass, plastic and paper.

Jamee: Found, eclectic and colourful with a little kitsch. I like a space to look playful and fun.

What makes your share house great?

Danny: Our pad is very much a reminder of how far we've both grown – from a lot of doubt to a natural confidence. Our apartment gives us a sense of home in the city.

Jamee: Knowing that we can both rely on one another to keep things sound.

What's one decorating secret you could pass on to other share house decorators?

Danny: A good balance of risk and control makes a space unique. It's almost like perfecting a recipe, you add and subtract until it feels right.

Jamee: Hit up second-hand places for a touch of personality with home decor. I have scoured many thrift, yard and estate sales, and have discovered some of my favourite home finds at these places.

What tip could you give other share housers about living in harmony with your housemate?

Danny: Respect. After all, it's their home too.

Jamee: I agree. Be respectful and clean up after yourself. No one wants a dirty roommate.

How do you and your roommate come together after a busy week of work?

Danny: We're both pretty busy. We're lucky to catch each other at all but once in a while we'll find each other at the same parties.

Jamee: Whenever we do see each other outside our busy schedules, we always catch up on the latest – what's new in his life, what's new in mine. This usually plays out while we listen to one of Danny's Spotify playlists. He has great taste in music and plays all the jams.

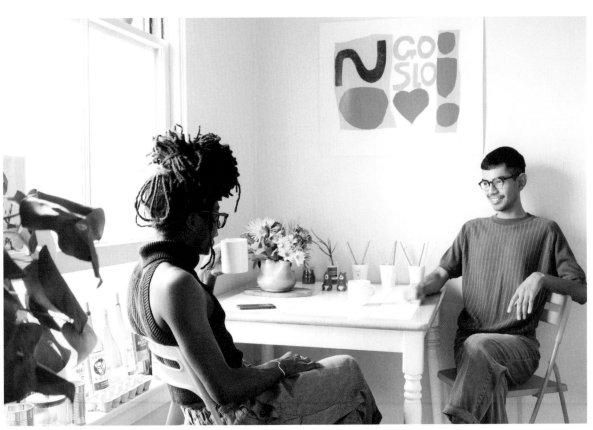

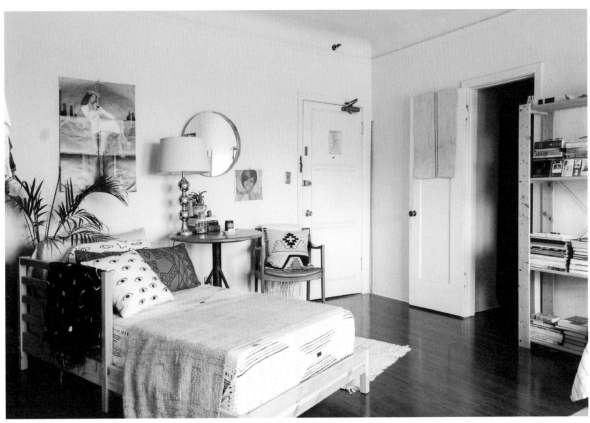

Sharing a retreat

WHO LIVES HERE
Al Morrow, Jeannette Francis, Dan
Brophy and Paul Wells (left to right)

LOCATION
South coast New South Wales

HOUSE SIZE
4 bedrooms, 1 bathroom

WORKING LIFE
Paul is an artist and furniture
designer; Dan is the director at Made
by Marcello; Jeannette is a journalist
and social commentator for SBS;
Al is an executive at a creative agency.

OF PARTICULAR INTEREST
Decorating was done on a next-to-
nothing budget with pieces sourced
from online marketplaces, the side
of the road, or gifted.

Escaping the city and heading down to that little house on the coast is something most of us only dream about. But two couples prove that it's possible to have a weekend retreat by adopting the share house lifestyle.

Paul, Dan, Jeannette and Al all live in the big smoke of Sydney, but share a beachside home in Bundeena on the south coast of New South Wales.

The couples met during a weekend away with mutual friends at a home in Berry. It was later in their friendship that Dan and Paul came to Jeannette and Al with the idea of renting a share house along the south coast together. As all the housemates loved getting away from the city, it made sense to invest in somewhere they could use as a retreat.

'The reason many people don't embark on the holiday home adventure is because they fear they may not use it,' says Dan. 'For me, the solution was finding a space close enough to home that it would be no greater distance than one could feasibly travel to work each day (one hour) and that the expense would be no greater than the amount I may spend on a "small trip" holiday every six months. Sharing a four-bedroom house between two couples meant the total expense over six months equated to around $1800 per person. That's pretty much the cost of a week in Bali. This way we get the benefit of a holiday every second weekend.'

It was actually the first house they inspected and Paul said he just knew it was meant for them.

TIP:

Housemates who save a small amount each month can invest in something really special together.

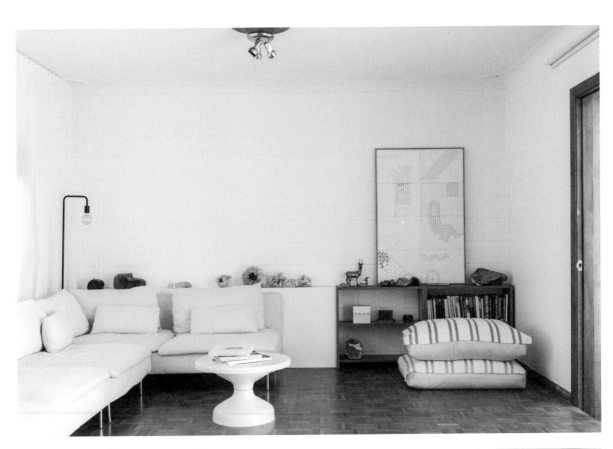

'I walked in and stood on the threshold of the sunroom looking out over the ocean, and I had the strangest feeling of deja vu, like I had stood in that spot a thousand times before. I just knew it was my house, there was no question about it,' he says.

The house needed a bit of TLC and Paul was the visionary behind its transformation.

The outdoor bathroom is a good example of Paul's ability and creativity. The wall is made of a huge pegboard that Paul fashioned from a full-size sheet of MDF and painted white. It functions as a coat rack along with an eye-catching arched console that he created from timber.

Paul had a very specific vision in mind for the decor. He believes that when decorating 'if you listen to a house, it will tell you what it wants to be'. He went with a mid-century Mexican-villa vibe, and the use of white with splashes of bright colour and dreamy floor-to-ceiling sheer curtains achieves this. If that isn't convincing, showering in the outdoor shower surrounded by cacti and succulents is bound to take anyone to Mexico.

As this was the housemates' second home, Paul worked on a tight budget. In fact, nearly everything in the house is second-hand, gifted or free off the street. Paul says he loves the hunt and is often surprised at what people will throw away.

The house is special to all of the housemates and each of them has a place where they like to sit down and take in their surrounds.

TIP:
Preloved items aren't just found online or in second-hand shops. Keep an eye out for interesting and high-quality treasures in kerbside collections.

For Jeannette, it's a spot on the couch that looks out onto the ocean. 'It's the best seat in the house. I love to sit back with a cup of tea and a laptop and work away while watching the waves in the distance, with a soft breeze on my face.'

'For me, it's early morning, sitting on a yoga mat on the parquetry timber floor in the living room,' says Al. 'Views out the big windows of blue sky hitting darker blue ocean and finally blending into dusty grey-green eucalyptus. Lying on the grass in the shade and watching the Test cricket on my phone – while every other sucker is back in town at work.'

The couples have been to the house both with and without each other, but agree it's best when they are all there.

'The house is not a timeshare. We are selling the concept of sharing the space together as a retreat, as a place to create and spend time together. So we attracted friends who wanted to buy into that concept,' says Paul.

When they do come together as housemates, it's usually over a delicious roast and some vino while watching *RuPaul's Drag Race* on the projector. They also like exploring Bundeena, going for swims at the beach and adventuring on long walks through the Royal National Park.

This isn't just a share house for these housemates, but somewhere they can come to reconnect with each other and nature.

TIP:

Take advantage of your area by exploring the local haunts and thinking of it as an extension of your home.

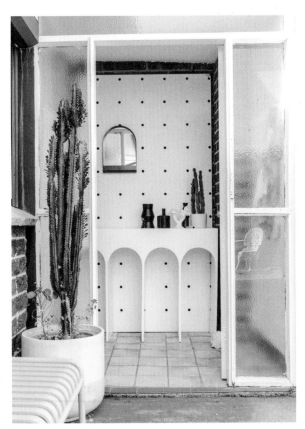

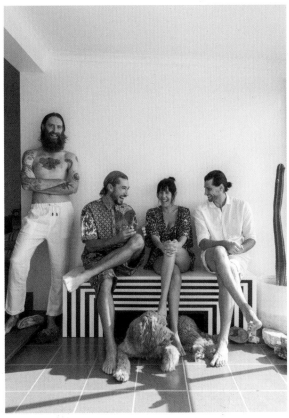

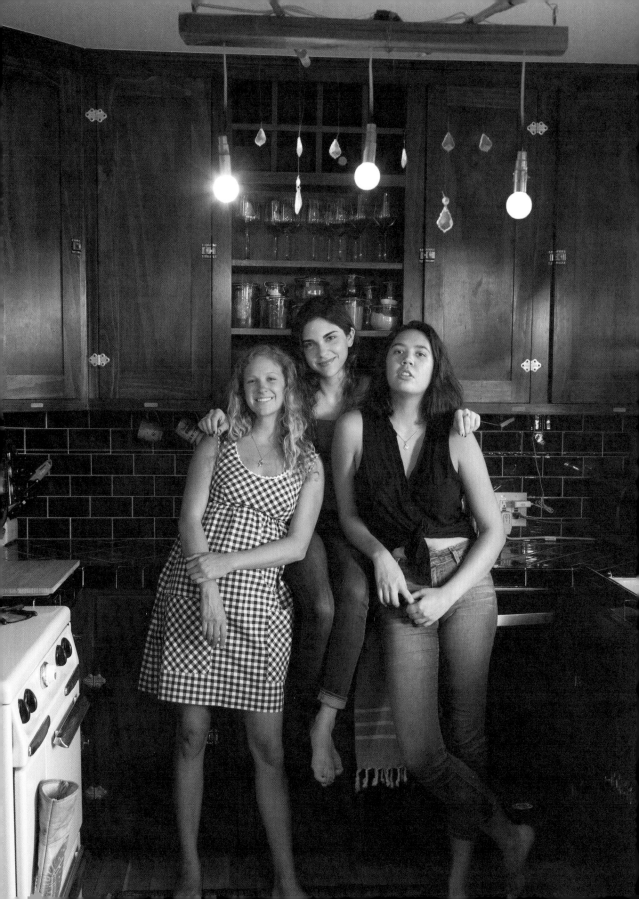

Living slowly

So often when decorating we rush to the finish line. We are so keen to make our new house a home that we run out the door and impulse buy things we look at months later and wonder, 'What was I thinking?' However, for these three housemates living in Silver Lake, Los Angeles, taking the time to decorate their share house piece by piece means that they are surrounded by treasured items that are not only accompanied by a story, but also bring them joy.

Each one of the housemates plays an important role in the overall character of the house. Jaya sets the tone through decor, Maggie displays her art collection and Steph gives the home a melody through her music.

WHO LIVES HERE
Maggie Shafran (left), Jaya Williams (centre) and Steph Sloan (right)

LOCATION
Los Angeles

HOUSE SIZE
3 bedrooms, 1 bathroom

WORKING LIFE
Jaya is an architecture graduate student; Steph is a musician, bartender and wine rep; Maggie is a portrait artist.

OF PARTICULAR INTEREST
The house boasts an original Matisse and several reproductions, and it is impossible to guess which is which.

How did you and your housemates meet?

Jaya: Maggie and I met during undergrad and Steph is a childhood friend of Maggie's from Sun Valley, Idaho.

How did you find your current share house?

Jaya: Ultimately through Craigslist, after searching through a variety of different avenues for months (numerous websites, word of mouth, and driving or walking around neighbourhoods looking for rental signs).

What is it you like about your housemates?

Jaya: We have found the perfect balance of best friend and roommate. We all have different schedules, so we're not on top of each other all the time, and we've established good boundaries for long-term liveability.

Steph: It's fortunate for us all that we are such close friends and confidants. In a city that can get as lonely as LA, it's a huge comfort and joy to know that some of my people are just a handful of steps and a door knock away.

Maggie: I love living with two of my really good friends. Some nights when all three of us are home we sit around the breakfast nook and just hang out and chat for hours. Jaya has an incredible eye for design and is always improving our home to make it more beautiful and functional. Steph is a wildly talented musician and I love hearing her tunes floating through our house.

What did the decorating process involve? Did you merge styles or did one of you take the lead?

Jaya: Maggie and Steph let me do everything – bless them.

What tips would you give to other housemates when they're decorating their share house?

Jaya: Go slowly. Collect intentionally. Don't be afraid to sell your stuff that doesn't work and pare it down to what makes you feel good to look at every day. You will be much happier this way. Also, invest in smart and attractive storage! This way clutter stays organised, you can hold onto important objects that don't work in your current space but that may work later, and it just makes day-to-day living in a small space much easier!

Why is it important to take your time when decorating?

Jaya: If you buy everything at once just to get the space filled, you miss out on the opportunity to find special pieces – or have those pieces find you! Moving time is usually a time of chaos (and consequently, poor decision making), so once that calms down, see how you move about the space and what your needs will be. Resist the urge to go on an Ikea spree!

What item in the house makes you most happy when you see it?

Jaya: The art deco flamingo lithograph mirror designed

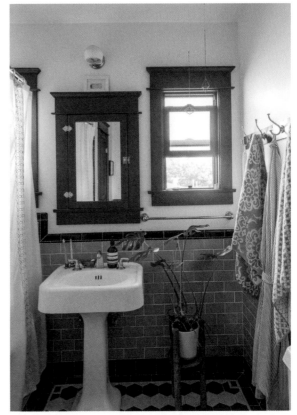

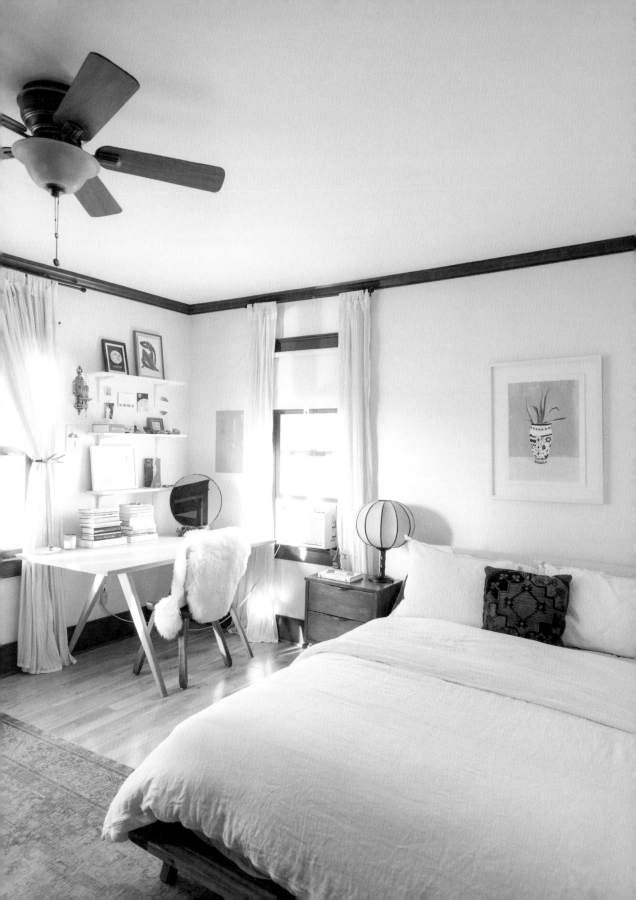

by Robert Stern that hangs in the corner of the living room. I imagine it to have this vaguely 1980s porn-star-chateau chroma quality, with pinks and greens and mysterious colours I can't describe. But what's so cool about it is that it could fit into so many different types of decor. It is one of my most cherished gifts.

Steph: I love the side of our refrigerator that's plastered with photo-booth strips. Every single one represents a celebration, an event, a kiss, a friendship, good energy. They remind me of who I am, who we are, and what the journey has been like to get here. They may give a new visitor the impression of how much of a lush I am. But that's another story …

Maggie: Jaya recently put a Himalayan pink salt lamp in the bathroom and it's like an adult night light.

Tell me a great story about a piece that you found and brought home.

Jaya: Maggie has these awesome 1980s mirrored tables – we call them the new-age-cocaine tables – from when she lived in Hong Kong. I would never have thought to buy something like that given the style of the house, but they really pop and add some unexpected silky fun to the space.

I have frequently brought home outrageous furniture objects that may initially frighten my roommates, but I think they've learned to reserve judgement until I've figured out what I want to do and where I want to put things. Then they always come around.

Where do you spend the most time in the house and what do you like about this space?

Jaya: I love our reading corner. It has a daybed my mum and I designed and had a carpenter build with lots of storage underneath. It is surrounded by these windows that have light flowing through at all hours of the day, but at sunset, oh man, it's stunning sitting there. You can see south for several miles, and in your immediate line of sight is this old Ukrainian church. It feels very magical. As for Steph – she plays a lot of music in the living room and Maggie cooks elaborate, mouth-watering breakfasts in the kitchen every day. Our breakfast nook probably gets the most traffic from all three of us. Together, we drink a lot of Steph-curated wine there.

Steph: I probably spend the most time in our communal spaces, be it the living room, breakfast nook, or our balcony. The natural light in these spots is conducive to my creativity and productivity. I usually play guitar and sing in the living room, and when I need to tweak lyrics or have people over to open a bottle (read: bottles) of wine, the nook seems to be the main hang. It feels intimate, but comfortable and communal. I can't tell you how many late nights and heart-to-hearts have come to fruition in that little built-in.

Maggie: I'm usually in my bedroom or the kitchen. I love cooking and it's so nice to have a well-organised and efficient space to work in.

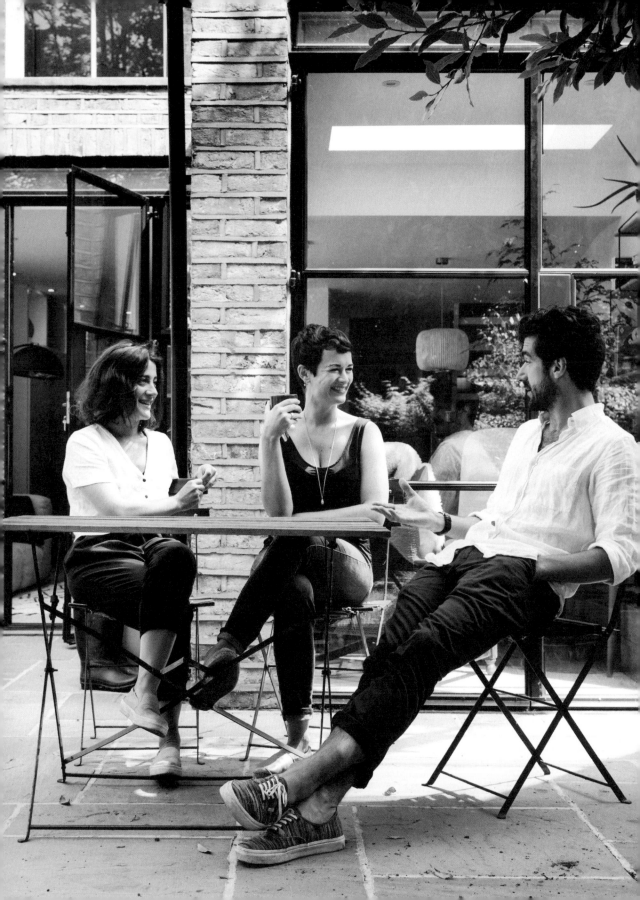

Lights, camera, action

WHO LIVES HERE
Olivia Thompson (left), Georgia
Oakley (centre), Nicholas Bishop
(right)

LOCATION
London

HOUSE SIZE
2 bedrooms, 2.5 bathrooms

WORKING LIFE
Georgia is a filmmaker; her partner,
Olivia, is a photographer; Nicholas
in an actor.

OF PARTICULAR INTEREST
This isn't just a house for living.
All three housemates are freelancers
and work from home.

Each of the housemates living in this Dalston share house is used to being either behind or in front of a camera and their home is definitely camera ready.

The style of the house is minimalist mixed with Scandi, which is Nick and Olivia's design preference. 'I like a house to feel cosy and lived in (although Georgia would disagree) but I'm quite obsessive about things being neat and put away,' Olivia says. Georgia is responsible for bringing in a touch of eclecticism, with the addition of books, plants and vases. 'We meet somewhere in the middle which is a perfect happy medium,' explains Georgia.

Evidence of this happy medium would be a statue of a sheep that sits in the garden. 'It's comically ugly. It's cobbled together using screws for ears, bolts for eyes and God knows what. Olivia and Georgia bought it at an antiques market and it's a warning to anyone getting

carried away when buying stuff for a house. Olivia still loves it,' Nick explains.

Olivia owns the house and had been sharing it with Nick before Georgia moved in. The house has become the perfect home for these three creatives. 'The house has to adapt around us for different aspects of our lives,' says Georgia. 'It needs to be a calm environment for me to write in, a practical studio space for Olivia to set up lighting rigs for test shoots, a place for Nick to learn lines for a play, an easy, open-plan space for a Friday night dinner party, and a cosy, relaxing space for those nights spent in front of the TV.'

This is achieved through the design. The Scandi decor, with its neutral tones and textured layers, adds warmth to the shared living room. Light pours in through the tall glass windows, which offer a view of the lush green garden – an ideal outlook when inspiration needs to strike.

TIP:

Decorating doesn't have to be at the cost of practicality. Create an inspiring and soothing workspace with lamps, plants and neutral colours.

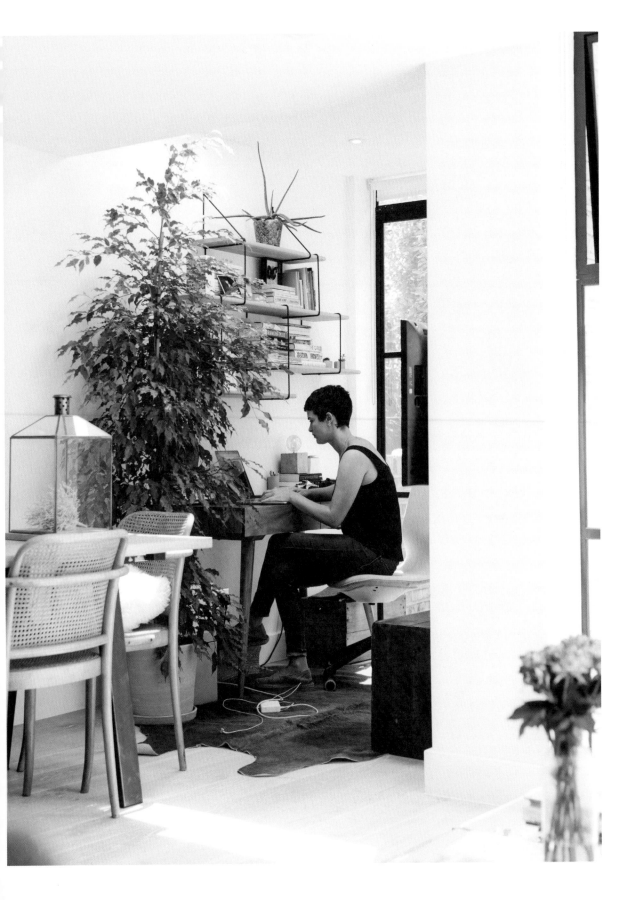

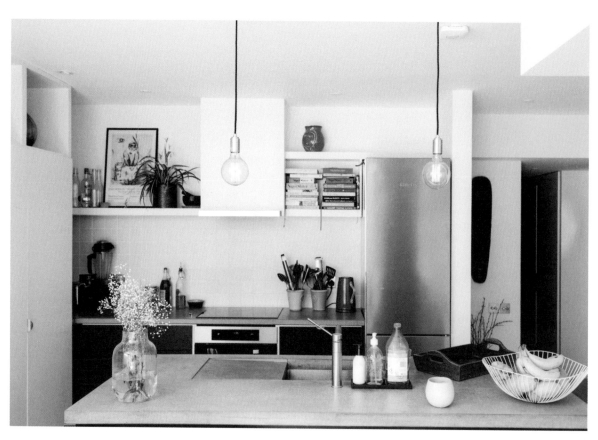

Breakout spaces for hours of concentration have also been considered in the design. These include Georgia's study nook next to her prized ficus tree in the living room, Olivia's desk space upstairs in their bedroom and the garden, which can act as another room for Nick to rehearse lines in.

Share housing in such a busy city like London can feel extremely transient and can seem like there is a revolving door process when it comes to finding the right housemates. 'The experience can be a little impersonal. Often it's just people renting out a room to make up the rent,' says Nick. It's for this reason that these three housemates appreciate the home and dynamic they have created, as it's a rarity. 'For me, it's where I feel calm and relaxed. I love the rituals I have at home. They feel grounding and reassuring and I always look forward to coming back to them if I go away,' says Olivia. 'As the nights in together in on the sofa seem to get more frequent as we get older, I've begun to really cherish that time spent together, without actually having to "catch up". It's those moments that make flat sharing special,' says Georgia.

While Georgia and Olivia don't spend as much time with Nick outside of the house, they use the shared spaces to come together and reconnect. Nick is the resident cook and Sundays are often a sit-down occasion for his wholesome roast chicken while summer time usually means a wine in the backyard.

'We laugh a lot, we talk a lot and we look out for each other. We probably don't socialise all that much outside of the house, but the house is definitely a shared space and we make a real effort to connect with each other when we're together,' Nick says.

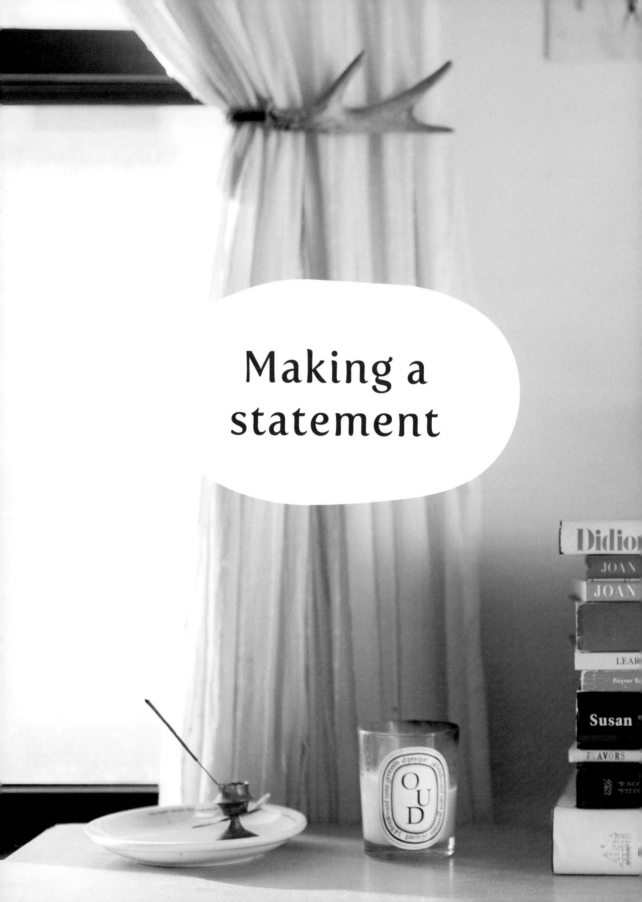

Making a statement

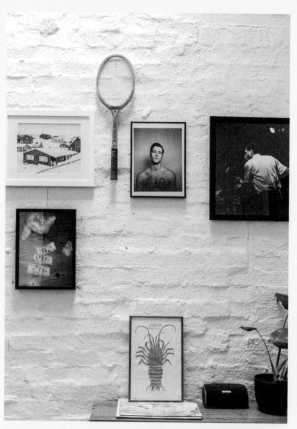
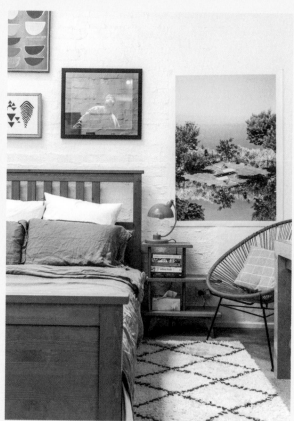
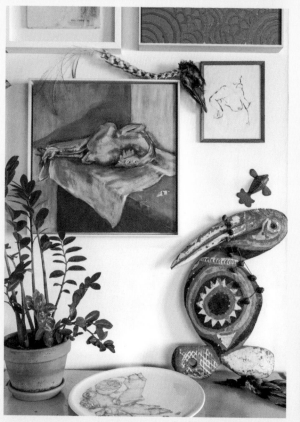
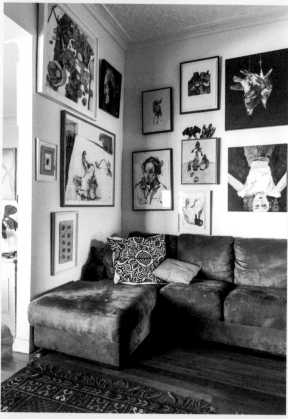

How to create a gallery wall

Living in a share house is a fun way to explore your style. It's a chance to be adventurous, test the boundaries and figure out what you really like.

There's nothing more personal than displaying your art. It is also a way to fill up those blank walls with some colour and interest and make your space more homely. If you have a small collection you want to hang, why not consider a gallery wall?

Maddy Worthington, who shares a two-bedroom home in Melbourne with Courtney Webb, curated the perfect gallery in her bedroom with original paintings and photography collected from friends and artists around the world.

1. CHOOSE YOUR HOOKS WISELY

Share housers who rent may find it difficult to get permission from their landlords to put multiple hooks in a wall, but there are temporary solutions always coming onto the market, including adhesive hooks.

'I was lucky, because when I moved in, there were already quite a few hooks in the wall, so I was able to use these and build around them with adhesive hooks,' Maddy says.

2. CHECK THE WEIGHT

You may have been told that adhesive hooks don't do the job properly, but they can work effectively.

Don't hang art on sticky hooks if it's too heavy. A good way to test this is the 'pinky finger' challenge. If the weight of the art feels too heavy lifting it on your little finger, chances are a hook won't be up to the task.

However, if you have the Schwarzenegger of pinky fingers, follow the load indication on the packaging and, if you're still worried, use more than one hook for the art.

3. PREPARE THE SURFACE

Make sure you clean the wall well and let it dry before sticking the hook. Some walls simply don't have the right surface. For example, bricks and some types of paint won't take adhesive hooks.

Finally, leave the hook for a day to let it set before hanging your artwork.

4. USE FISHING LINE

One of the tricks Maddy has used in her bedroom and also on the job while set decorating is to connect artwork with fishing line.

'It means you save yourself from putting extra hooks on the wall and the artwork lines up evenly,' she says.

Measure how much distance you want between the artworks when they're hanging, cut the appropriate amount of fishing line and tie the frames together from the back, using either the canvas backing or the hanging string. Then simply secure the top artwork to the wall and the bottom frame will hang from it.

5. DON'T BE TOO PRECIOUS

Above all, don't be too precious with gallery walls. 'I think people get caught up with a gallery wall being perfectly measured out and distanced, but there's something really nice about it being a bit scattered and uneven,' says Maddy.

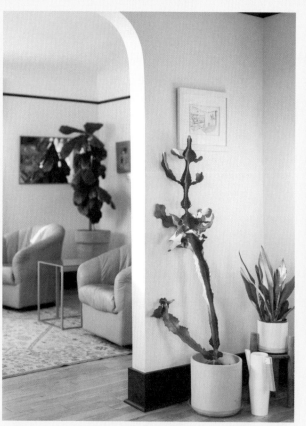

Plant parenting 101

A lot of novice plant parents turn away from greening up their space because they don't believe they have the talent to be a successful indoor gardener. However, Simon Roberts, an urban farmer in New York, believes that everyone is capable of keeping a plant alive. Simon runs his own architecture firm called Allott, which is dedicated to helping cities grow in harmony with nature in the shortest possible time through agriculture, design and community. Currently he works with schools across New York to grow farms on their grounds.

Despite living in a concrete jungle, Simon always tries to be surrounded by nature, which is clearly evident in the Brooklyn apartment he shares with his brother Ward. Simon had the following advice to give to people who love the idea of decorating with plants but are worried that their black thumbs will work against them.

1. BRING NATURE INTO THE HOME

I think we all inherently know that we need nature in our lives. When we live a lifestyle completely devoid of any nature we know something is missing. But when you have plants in your space, you actually feel better. I think the more we look after nature at home, the more we might look after nature outside of the home as well.

2. CHOOSE PLANTS CAREFULLY

Firstly, find a good place to buy quality plants. Go to a farmer, meet the maker, go to the place where it was grown. Nurseries don't always stock the best quality plants.

You should also start with a small plant – something that you can see every day and give your attention to. Something you can put on your kitchen table.

I always bring a mother-in-law's tongue into the bedroom, because it gives off more oxygen than other plants. In the living room, I love a good palm and in the bathroom, devil's ivy is your best bet for humid low light.

3. GROW PLANTS IN SMALL APARTMENTS

I've always believed that the smaller an apartment got, the more nature I had to bring in. When I was living in Hong Kong, I was in an apartment that was about 27 square metres. I started growing stuff I brought in from outside and it made the space feel better.

4. MAKE A TERRARIUM

What I'm liking at the moment is moss. Get out of town and find some moss and make a little terrarium. Look at the precipitation on the glass in the morning – that's how you know the plants are well hydrated. Open the top of the terrarium and inhale – it's like one fresh breath of the forest. Terrariums can also thrive in a dark room.

5. KEEP PLANTS ALIVE

Make sure you water plants regularly although be careful not to overwater. A really good way of watering plants is to use ice blocks because they are absorbed at a slower and more even rate. And definitely talk to your plants.

Styling a shelf

Sometimes the best place to start as a novice decorator is to style an empty shelf. It's a canvas you can have fun with and show off your personality. It's also easy to change around and build on over time as you become more confident with your style.

1. CERAMICS AND SCULPTURE
There are so many artists producing eye-catching ceramics, which make perfect ornaments for a shelf. Think of Milly Dent whose pieces play with inky blues in whirlpool-like effects, Alterfact with their amazing 3D-printed vessels and Amy Leeworthy who has a real 1960/70s vibe to her products.

To make your shelf display extra special, you could also try making something yourself. Taking a pottery or sculpture class isn't just a great way to practise mindfulness. It also means you will end up with one-of-a-kind pieces you have full bragging rights to.

2. BOOKS
Coffee table books look beautiful stacked vertically, or even horizontally for more impact. Switch them around regularly and make sure you read them – there's something a bit cringe-worthy about having books purely as decoration.

3. ARTWORK
Artwork comes in all shapes and sizes and smaller, lighter pieces will sit perfectly on a shelf. This also means you avoid having to figure out how to display your art on the wall.

4. PLANTS
Smaller plants work well on shelves too because they work just about anywhere. Devil's ivy and string of pearls look lovely draped over the side of a shelf.

5. COLLECTABLES
If you have a collection you don't want to hide away, display it on your shelf. It could be a prized record collection, crystals to bring your home the best energy, or even something a little more left of field, like Japanese miniatures. Weird curiosities can be a great choice as well – they're the things that make people stop, tilt their head and ask, 'Where did you get that?'

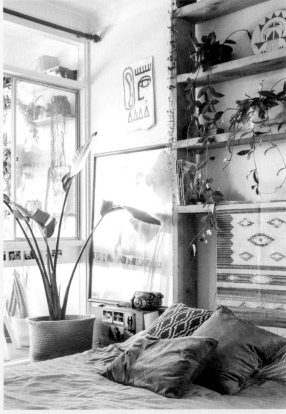

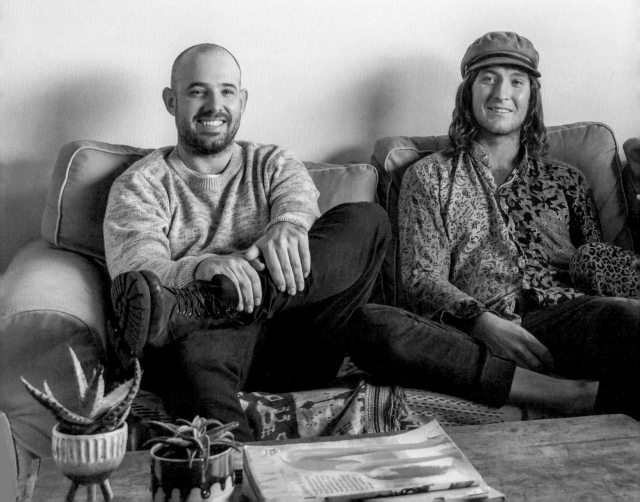

Swept away by the waves

WHO LIVES HERE
Jimmy Johnston (left), Danny Sherry
(centre) and Andi Plowman (right)

LOCATION
Sydney

HOUSE SIZE
3 bedrooms, 1 bathroom

WORKING LIFE
Andi is a creative director/stylist;
Danny is a builder; Jimmy is an
environmental scientist.

OF PARTICULAR INTEREST
Two of these three housemates have
known each other since childhood.

Freshwater is a suburb in northern Sydney and is one of those idyllic spots where the Aussie surf, sun and sand still rule local lives. Andi, her partner, Danny, and their long-time friend Jimmy have settled here in a small but dreamy apartment where they can pop open some ice-cold beers and listen to the waves crash.

Danny and Jimmy met Andi in Manly when she moved from Melbourne. They connected over their affinity with the beach, each having grown up next to the water – Danny and Jimmy in the northern beaches of Sydney and Andi in Byron Bay.

Although Manly served them well as three young students enjoying the local nightlife with classic hangover recoveries on the beach, the three of them decided to seek greener pastures and veer away from the more fast-paced lifestyle. 'Freshie has always been my favourite place in Sydney, even when visiting from Melbourne, so I was super stoked when we moved here. The rent is pretty outrageous, but our beach is one of the best surf breaks in Sydney, with amazing rock pools and headlands, which definitely makes up for high rents,' says Andi.

Their apartment is just a short stroll from pristine beaches and is styled straight out of the 1960s and 70s surf culture, with the housemates' love of music, the ocean and nature influencing their decor. Luckily for these three housemates, they share a similar style, which means decorating was a joint effort. However, each has a favourite piece. For Andi, it's the huge portrait of Jimi Hendrix in the living room painted by a friend, Patty O'Connell. For Danny, it's the original *Endless Summer* poster by his good mate Nick Potts, and for Jimmy, it's their impressive plant collection. 'I love the amazing and luscious plants that Andi brings home every day. I think we can't bring another one in, but she always manages to find the perfect spot for it,' says Jimmy.

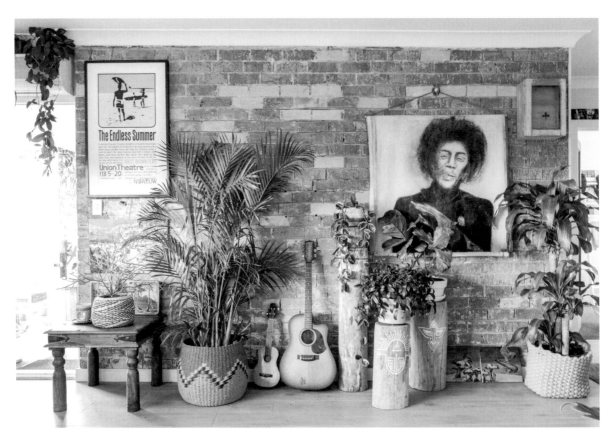

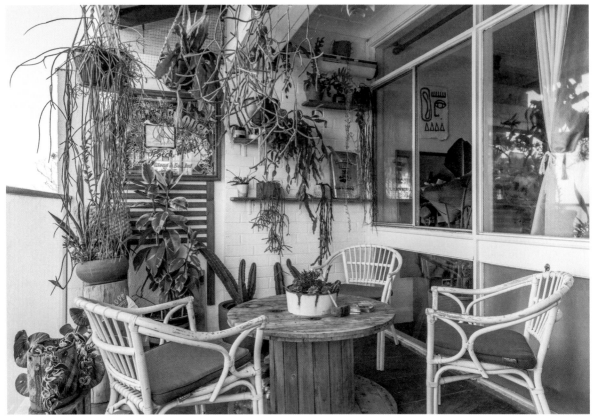

Of course, these precious plants need to be shown off in all their glory and there's no better prop than one of the timber totems made by Andi and Danny. The couple co-own Snake Charmer Creative through which they source and decorate timber totems with unique designs, as well as working in interior and plant styling and selling commissioned artwork.

The plants are found throughout the house and not a room misses out on some greenery, from the kitchen and the bathroom to the living room and the balcony. Being at one with nature sure looks good.

The housemates share playful personalities. They love a dance around the living room and some cheeky drinks at the end of the day. Their fun side is revealed in the wall decor. A photo gallery covers the wall at the breakfast bar showing off all the good times these three have shared together. Andi and Danny also opted to put their hat collections on display in the bedroom. By hanging them on the wall rather than storing them away in cupboards, they have created a bold and fashionable statement. Both are so proud of their hats that it almost feels like a trophy room.

Although the apartment is small, the three housemates don't feel like they're living on top of each other as they spend a lot of time exploring nature's playground, swimming, surfing and camping. 'Danny and I both have a deep-rooted love of the outdoors so we go camping every few weeks somewhere new,' says Jimmy.

Having kept the bond strong for many years now, Andi, Danny and Jimmy have found their perfect pad and their perfect housemates, and they don't plan on splitting up the band anytime soon. 'We're an unrelated family that likes to joke about everything and have a good laugh,' Danny says.

When entrepreneurs decorate

Felix and Cord are two young, ambitious housemates living in Berlin. They share their apartment and their start-up, which helps new business owners break into the German market. Their sleek contemporary apartment is constantly evolving as new pieces of decor are regularly added. Their home offers a safe place to chat about business goals and experiment with new decorating ideas – a combination built on the back of years spent as friends and housemates.

WHO LIVES HERE
Felix Arhelger and Cord Schmidt

LOCATION
Berlin

APARTMENT SIZE
2 bedrooms, 1 bathroom

WORKING LIFE
Felix and Cord run a consultancy company together.

OF PARTICULAR INTEREST
The piano in the living room is over 100 years old and once belonged to a famous cartoonist from Berlin.

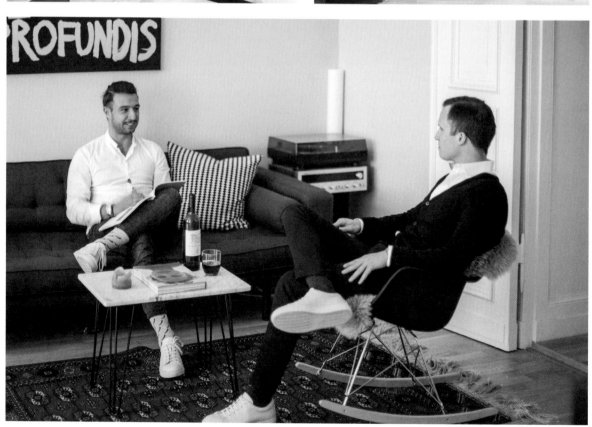

What do you like most about your share house?

Cord: We completely refurbished the apartment, so we took care of basically all aspects of its design. We built most of the furniture ourselves and took lots of time to choose the other pieces, but it keeps changing and evolving. For example, in the past months we focused on bringing more art into the apartment. We have assembled some rare works in contrast to other findings like a real life-sized medical skeleton.

Felix: What I like most about this place is that it really gives us a feeling of belonging somewhere. We travel a lot and coming back here means to get away from the – I would call it the airspace aesthetic of places – where everything looks the same. The aesthetic here really thrives on differences. Pieces here don't all fit together, as parts of life do not always fit together. But this place reminds me that this is okay.

How did you meet?

Felix: We've actually been living together since we met in university. We lived together with some other friends in a very old villa for three years where we could basically do anything we wanted.

What do you like most about shared living?

Cord: The most relevant aspect about shared living is that you can retreat to your own room, but if you want some company, there's always the opportunity to do something together.

Felix: I would say the best part is that you can live together while not living together. There is always somebody to discuss things with in-depth, with the clear understanding that nothing is meant personally. We've known each other for a very long time now and can anticipate each other's mood.

What do you both do for work?

Cord: We both have a rather diverse work schedule. While we were both pursuing a career in cultural studies and sociology, we also founded our own business two years ago. We consult with companies on their market entry into Germany, buy their trade rights and sell them to other resellers.

Felix: We have the strong opinion that fulfilling yourself does not mean sitting for more than forty hours a week in an office. We work to live (or to think), meaning at this stage of our lives the work provides the means for us to do what we like to do – with the goal to do that at any given time.

How would you describe your decorating style?

Felix: Rather eclectic – but I think that everyone says this. So I would describe it as something that is really romantic. This place can seduce you when the candles are burning, but it can also have a very sharp edge and provide you with an environment where you can think.

Cord: You can see several styles and epochs. For example, the coffee-house chairs bring in a nineteenth-century feel, whereas the bookshelf, table and couch are referencing mid-century chic – totally en vogue. And,

157

as Felix said, we have candles everywhere. When we have friends for dinner, we try to light the room only with candlelight.

How have you merged styles?

Cord: Well, someone said that style has merged us. But I think that goes just a little bit too far.

Felix: I think we kind of managed by refurbishing the apartment. Building the furniture was a process we planned and executed together, so what came out in the end was a perfect mix of what we both like.

What are your favourite pieces in the house?

Cord: I'm not sure. We have this old lectern from my grandfather, who was a forensic pathologist and travelled a lot to give talks and lectures. For some reason, he always took this huge thing with him, even if he went on a trip to Japan. That's somehow crazy and somehow really cool.

Felix: I'd say it's definitely the piano for me. I wish I played more (and better), but this is just a piece I really love. I got it by chance and then I discovered that it is the piano of a famous cartoonist from Berlin and over 100 years old. So that also brings something to its charisma.

What do you like about living in Berlin?

Felix: I think there's a lot to it. You could of course say what probably everyone says – 'the city's eclectic atmosphere'. But it's really what only a few cities have, and certainly no city in Germany, where you have all those really different districts. I love strolling around the streets on Sundays, sipping a coffee or a drink.

Cord: Definitely. What's also cool about Berlin is that there's always something to discover. It's a cliché, but it's actually true. I keep finding places and restaurants or bars that I had never heard of before, or suddenly I find myself in this great museum or cafe.

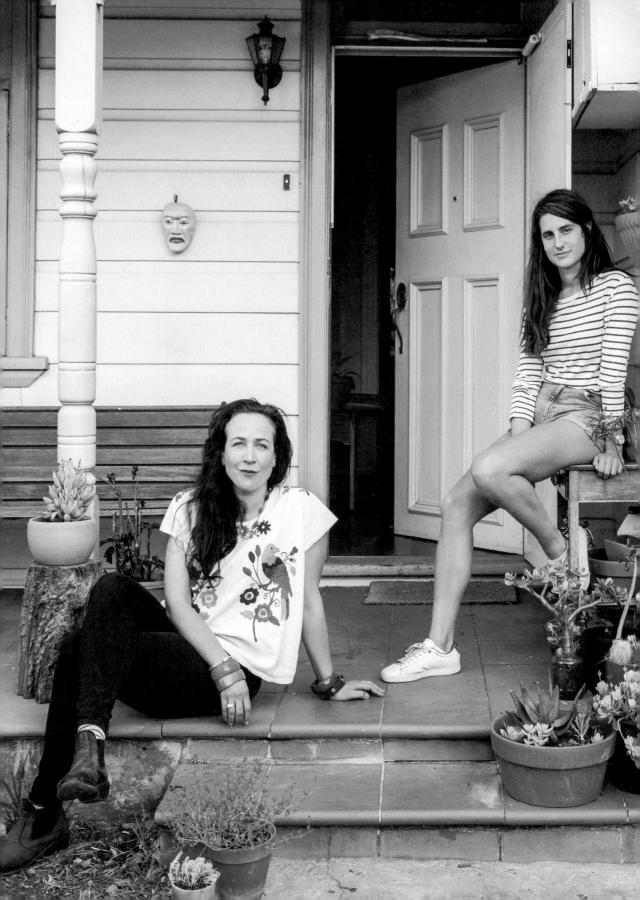

Art, feasts and friends in a weatherboard cottage

WHO LIVES HERE
Mirra Whale (left) and Kata
Mandic (right)

LOCATION
Sydney

HOUSE SIZE
3 bedrooms, 1 bathroom

WORKING LIFE
Mirra is a practising artist; Kata
works in film and TV development.

OF PARTICULAR INTEREST
Mirra contributed to the renovation
of the kitchen – probably every
landlord's dream – and fitted it with
top-quality appliances.

From the outside, Mirra and Kata's three-bedroom, weatherboard cottage in Sydney looks similar to many of the others on their suburban street. However, venturing inside, a world of fine art, love of good food and a true sense of sharing is found.

Mirra is the longest-standing housemate and chief decorator, while Kata moved in after being introduced to Mirra through her sister's boyfriend. The two bonded over a delicious home-cooked meal and a glass of wine before deciding to live together.

Living with another creative was a prerequisite for both of them. 'Living with other artists and creatives over many years has been a wonderful experience and inspiration to the way I live my life and my art practice,' says Mirra.

The first striking element of this share house is the incredible gallery that lies within. Every wall is covered with art that would make any collector envious. Luke Sciberras, Tamara Dean, Ben Quilty, Guy Maestri, Clara Adolphs and Laura Jones are just some of the artists whose works decorate the common areas, along with many other works and artifacts collected throughout world travels.

'Whenever a new piece is introduced into the space, there tends to be a reshuffle. I love coming home to discover there is a new hang of artworks – it always makes me appreciate them in a new way,' says Kata.

Mirra and Kata sleep at the front of the house where the best sunlight streams through the windows and the charm of the old cottage features can be

TIP:

Don't be afraid to change your space. Curating your pieces in a different way can give your whole home a fresh look.

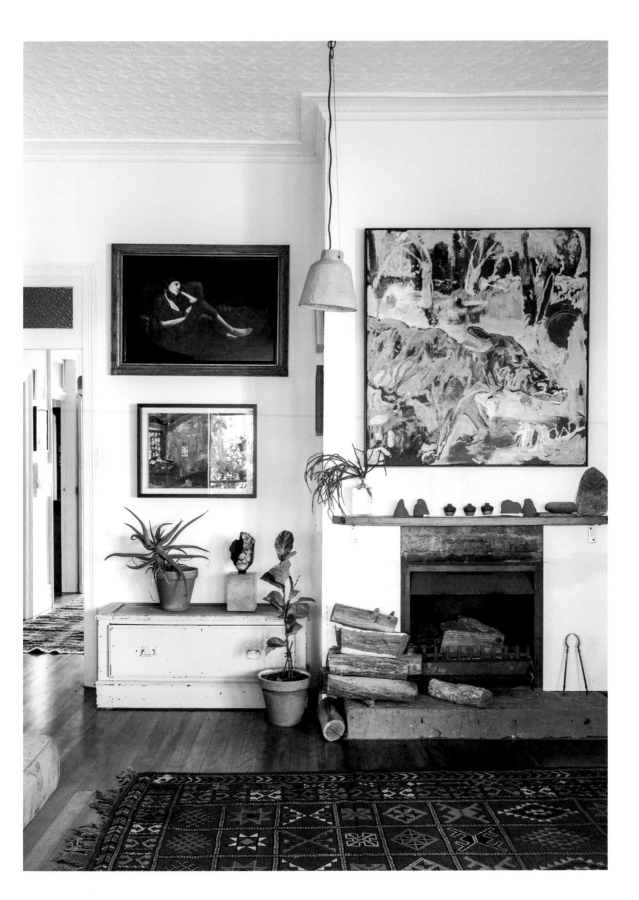

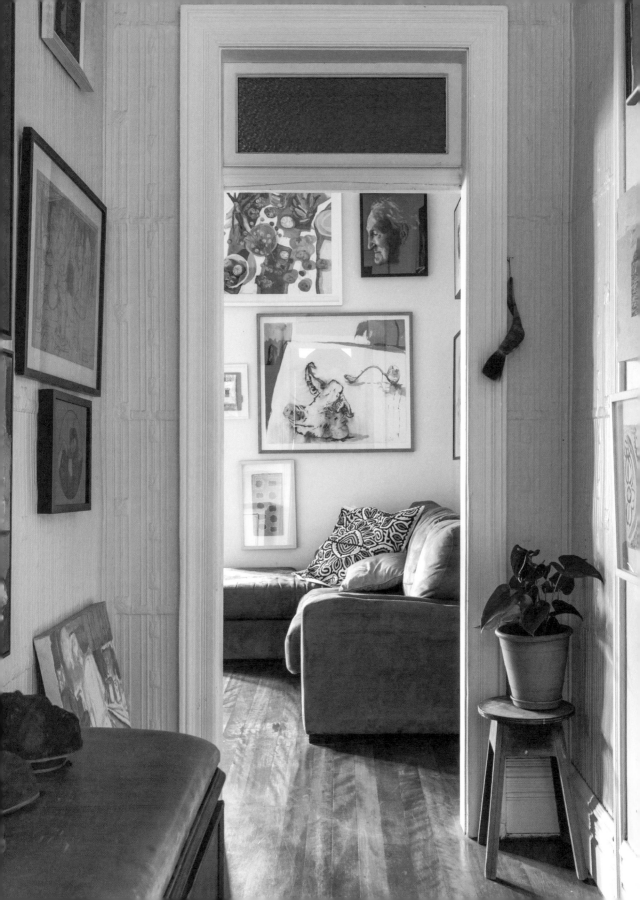

appreciated. The pressed tin walls and timber floorboards that had previously been covered up by carpet evoke a time long gone. The third bedroom is used as a spare, a luxury that resulted when their third housemate and fellow artist, Laura Jones, moved out.

One of the most heartwarming aspects of this household is the way previous housemates have left mementos of themselves in the decor. Laura's art hangs in the living room and the stunning oak dining table her brother made her for her 30th birthday is still the hotspot at dinnertime. Another former housemate and ceramic artist, Alexandra Standen, also left her mark with a bountiful supply of handmade bowls and plates. These reminders of past housemates have seamlessly become incorporated into Mirra and Kata's everyday life.

While there's a lot of love throughout this house, the real heart of the home is the kitchen. Mirra and Kata are impressive foodies and often cook for each other. Forget about the clearly labelled fridge with off-limit items regularly associated with a typical share house – this household favours a 'what's mine is yours' attitude. 'I have always lived in houses with friends, or friends of friends, that quickly become a home. We share shopping and chores, and cook feasts to eat together. We operate more like a family unit than as housemates,' says Mirra.

The kitchen is also the space that received the biggest makeover. Mirra worked with the landlord and friends to renovate it into a modern galley kitchen. With a previous career in hospitality, Mirra knew how

TIP:

Housemates don't just have to share spaces. Consider living with people with whom you can enjoy sharing other things – like art or cooking.

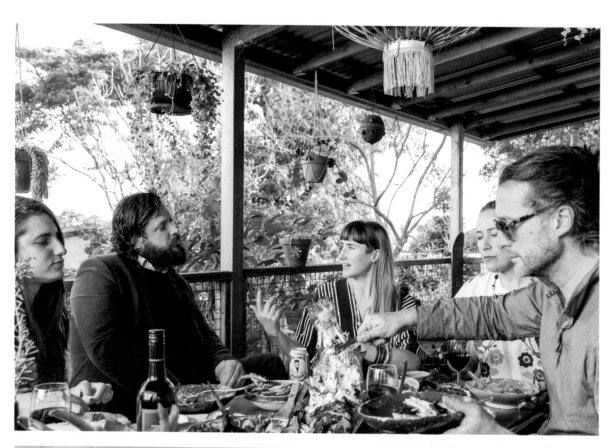

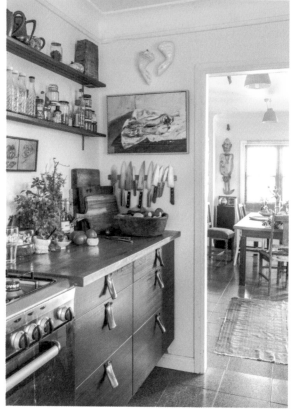

to create a functional kitchen with the addition of open shelving, a gas-top stove and ample benchtop space. It's not devoid of unique creative touches either. The leather handles on the cabinets were fashioned out of an old handbag of Mirra's, and the beautiful stained-glass window at the rear of the room was found by friends on the side of the road in Bondi.

While feasts are prepared in the kitchen, the essence of sharing is felt most when it's time to eat. There's nothing these two love more than having their friends over to share a meal, laugh and drink a bottle of red around the open fireplace, or out on the lush green verandah when the Sydney sun is shining down.

TIP:

Renting doesn't have to mean you can't make changes. Ask your landlord to consider small renovations for a split cost or share of the labour.

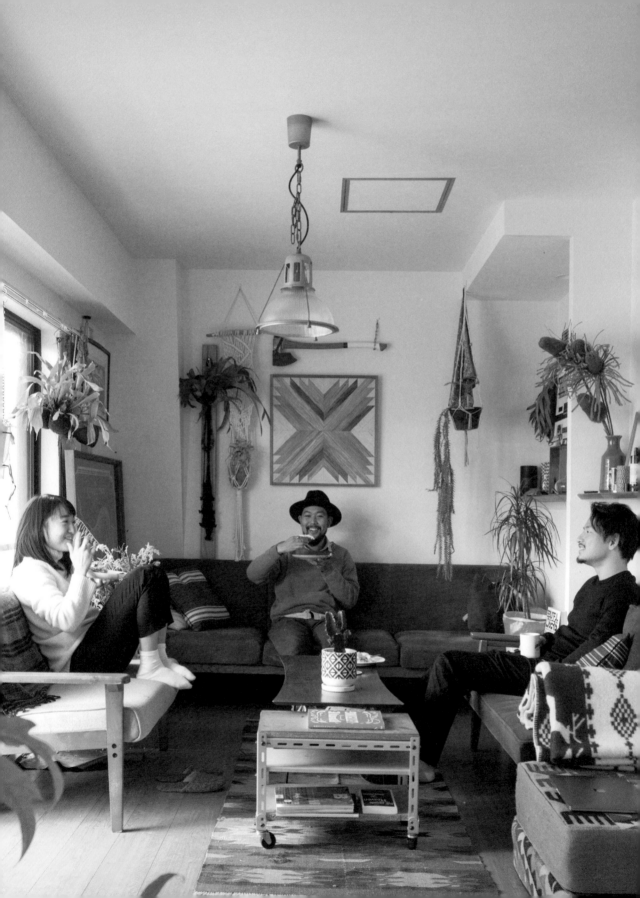

Two bros in Tokyo

WHO LIVES HERE
Keisuke Masuda (centre) and
Taku Izawa (right)

LOCATION
Tokyo

APARTMENT SIZE
3 bedrooms, 1 bathroom

WORKING LIFE
Kei is a freelance barista and works
for creative studio TERASU; Taku
works at Google and is also a
lettering artist for Paint & Supply.

OF PARTICULAR INTEREST
Taku and Kei host Airbnb guests
at their apartment and have so far
hosted more than 200 guests.

In Tokyo, it's more common for millennials to live on their own than with a housemate, but this didn't suit two very social young men, Taku and Kei, who not only wanted company after a long day in the city, but also to meet new people. They love the chance to cross paths with international visitors and so they rent out the third bedroom in their apartment in Meguro. So far, with over 200 guests passing through their doors and counting, this is by far the most widely shared space featured.

Taku led the way in design and found an eclectic mix of pieces from across Tokyo. He learned about his own style through curating their shared apartment and, luckily for him, Kei has very similar taste, which made the process much easier.

'The reason why I like decorating our apartment is that I like to make people feel good with my design. Sometimes my friends and guests give me good feedback about my decoration and that's the most fun part for me,' Taku says.

The living room is open plan and has a bi-fold door that attaches to a creative workspace where Taku often spends time on his artwork and fools around on his keyboard. There is a folk style to the shared living space with its warm colours, kilim rugs and Aztec patterns. Hanging plants and dried branches also create a relaxed, welcoming feel and bring a touch of nature into a home that's located in one of the busiest cities in the world.

Taku's typography features on chalkboards around the apartment with slogans changing regularly. This is Kei's favourite decorative touch, whereas Taku favours the three-seater couch he bought from Track Furniture. 'It's an admired furniture maker in Japan and I always wanted to have a couch from there. Everything is made by hand so I waited for six months after ordering the couch,' says Taku.

TIP:

Take advantage of your strengths when bringing something into your home, whether it's a keen eye for design or sharing your knack for cooking or music.

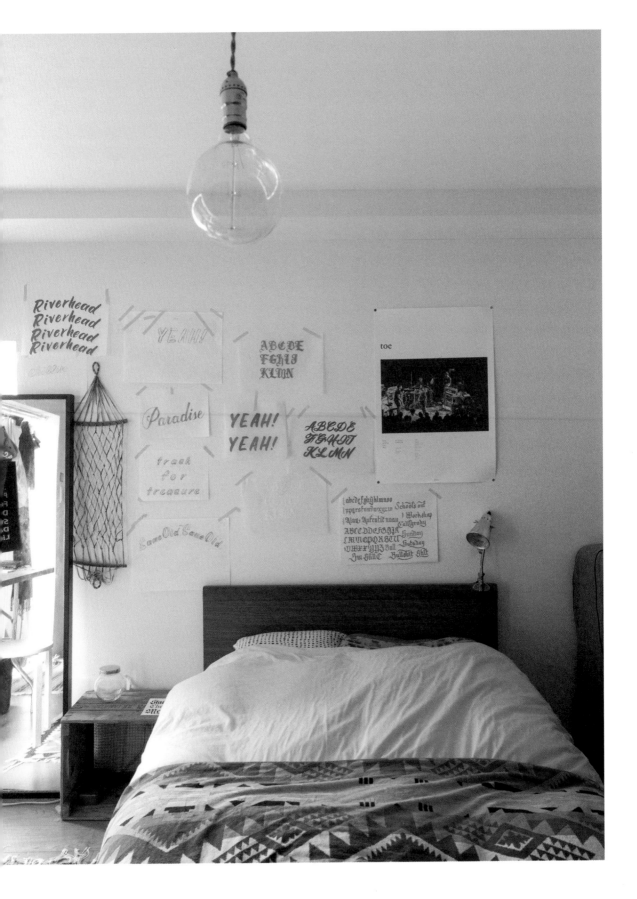

This shared apartment is practice for Taku as a decorator and host as he aspires to one day own his own hotel. His ultimate goal when styling a space is to create an atmosphere that makes people happy. 'I believe good design creates a good time. When we go to fancy restaurants, cool cafes, nice hotels, we feel good and special. I wanted to provide the same kind of feeling at home as well,' Taku says.

While Taku creates an inviting space for guests aesthetically, Kei makes them feel at home with freshly brewed coffee daily. As a freelance barista, he finds himself in amazing cafes and at events across this bustling city and has even poured lattes in Australia in Byron Bay, where he worked for two years. Japan has a strong speciality coffee culture with most baristas grinding coffee to order. The beans are imported from renowned coffee-growing countries across the globe, including Kenya, Guatemala and Colombia. Learning about coffee and trying different batches is one of Kei's passions. 'I like cooking with coffee too. It's my number one favourite ingredient,' he says.

The two housemates have found it easy living together and have become friends in the process, often sitting down in the living room with a coffee – made by Kei of course. 'The reason why I live in a share house is that I want to have a good time with someone at home,' says Kei. When asked what the golden rule for living in harmony with a housemate was they had very similar answers, which essentially came down to mutual respect. 'Keep tidy all the time. Also, always care about your housemate and about how they feel,' says Kei. 'Always think about someone else,' says Taku. 'If you don't do the small chores your housemate will have to, so when you realise that, you do them right away.'

ARTWORK CREDITS

11 Bottom right:
Artwork by John Olsen

18 *Brendan de la Hay*
Kathrin Longhurst

35 Artworks by Khalil Gibran
(left) and Rebecca Amad
(right)

50 Top:
Artwork by Janet Hanchey

Bottom left:
The Chickadee
Martin Swift

Crows by Jim Reed

Artwork by Deanna Mance

Bottom right:
Artwork by Adriana
Scalamandré Bitter

59 Top left:
Paintings on shelf by
Maddy Worthington

Decorative plate on second
shelf by Bonnie and Neil

Top right:
Artworks by Maddy
Worthington, Sandra
Eterović, Todd Anderson-
Kunert, Lucy Gouldthorpe
and Amy Joseph

60 Wedding backdrop by
Courtney Webb

79 Bottom right:
Artwork by Sonia Clerehan

80 Artworks on wall by Mali
Robinson (left) and Josephine
Napurrula (right)

123 Top:
Relief sculpture by Paul Wells

124 Artwork from photographic
series *Dwelling* by Paul Wells

132 Artwork above bed by
Reed Burdge

138 Bottom right:
Print by Edvard Munch

142 Top left:
Artworks and photography
by Kate Molenkamp, Ben
Clement, Rob Cordiner and
George Foulds

Top right:
Ghost Face Killah
Ben Clement

Gonzo
Lucien Graetz

Original artworks by
Maddy Worthington

Bottom left:
Reclining cock
Mirra Whale

Life drawing by Mirra Whale

Sculpture from Papua New
Guinea by unknown artist

Bottom right:
Asian green grocer
Laura Jones

Tom Uren
Mirra Whale

Pig's head
Luke Sciberras

Clay pigment painting by
Hazel Ungwanaka

Discarded Bird
Mirra Whale

Etching by Luke Sciberras

Bird painting by Guy Maestri

Ink portrait of Luke Sciberras
by Elisabeth Cummings

Still life
Matilda Julian

Self portrait
Laura Jones

The Scribblah
Ben Quilty

144 Bottom right:
Jimi Hendrix by
Patty O'Connell

151 Top right:
Morning of the Earth
original posters

Skateboard by Snake
Charmer Creative

Bottom left:
White painted eagle on
timber board by Snake
Charmer Creative

152 Top:
Jimi Hendrix by
Patty O'Connell

163 *Tamara Dean*
Mirra Whale

Perished
Luke Sciberras

Self portrait, cast
concrete sculpture
Guy Maestri

Small blue porcelain
sculpture of mountains
(on mantelpiece) by
Alexandra Standen

Terracotta light shade by
Alexandra Standen

164 *Asian green grocer*
Laura Jones

Tom Uren
Mirra Whale

Pig's head
Luke Sciberras

Clay pigment painting by
Hazel Ungwanaka

166 Bottom left:
Porcelain pig trotters by
Juz Kitson

Friday night boar
Mirra Whale

Bottom right:
Portraits of Philip Nitschke by
Mirra Whale

Photograph by Tamara Dean

Landscape study by
Luke Sciberras

Portrait by Julian Meagher

168 Wood art by Aleksandra Zee

171 Typography and artwork by
Taku Izawa

PHOTOGRAPHY CREDITS

PABLO VEIGA
Instagram: @pablo_veiga
pabloveiga.com
6, 8, 11, 18, 21, 22, 25, 32–3, 35, 36,
40, 43, 44, 56, 59, 60, 69 (bottom left
and right), 76, 79, 80, 88, 91, 92, 95,
120, 123, 124, 127, 142, 144 (bottom
right), 147 (bottom right), 148, 151,
152, 160, 163, 164, 166

JULIA ROBBS
Instagram: @juliarobbsjuliarobbs.com
12, 15, 16, 46, 49, 50, 64, 69 (top),
144 (top right and bottom left)

LIZ SEABROOK
Instagram: @lizseabrook
lizseabrookphotography.com
Front cover, 26, 29, 30, 39, 82, 85, 86,
134, 137, 138

MASAO NISHIKAWA
masaonishikawa.com
52, 55, 98, 100, 168, 171, 172

CLAUDETTA BÖTTCHER
Instagram: @doitbutdoitnow
doitbutdoitnow.de
62–3, 70, 71, 72, 75, 108, 111, 112,
147 (top and bottom left), 154, 156,
159

CARLEY RUDD
Instagram:@carleyscamera
carleyrudd.com
114, 116, 119, 131, 132, 140–1,
144 (top left)

DABITO
Instagram: @dabito
oldbrandnew.com
96–7, 104, 107

FOX BROADCASTING COMPANY
102

ANDREW HEISER
Instagram: @mistaheiser
128

ABOUT THE AUTHOR

Emily Hutchinson has been
writing for years about interior
design and has a passion for
producing content concerning
young decorators on a budget.
Her writing career has taken
her across the world exploring
creative spaces and speaking to
people with big ideas and unique
backstories. She also lives in a
share house in Melbourne with
two housemates and enjoys
improving her home with a new
treasure whenever she can.
Follow Emily on Instagram
@sharedliving.